Happy Birthday!

Love,

ROUTINE ART CO.: COLLABORATIONS

Printed and bound in Great Britain by
Aldgate Press, London E1 7QX
Typeset by Counter-Point, Camberwell

Book Design by Graham & Graham

Cover Illustration shows ...
Photographix by Edward Woodman
End photo by Nick Baxter

ISBN 1 870736 001

WORKING PRESS

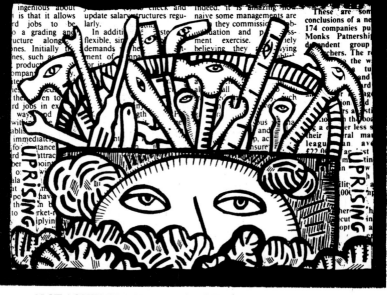

85 ST AGNES PLACE, KENNINGTON, LONDON SE11 4BB

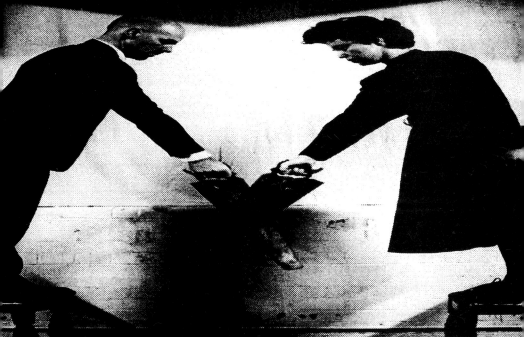

SINGLE IMAGE PERFORMANCE BY MONA HATOUM · Edward Woodman

collaborations

ROUTINE ART CO.

compiled by Stefan Szczelkun

contents

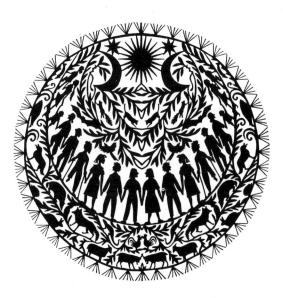

PAPERCUT BY JOLA SCICINSTA

introduction

I grew up with working class parents, both displaced from their own culture, in the London suburbs. It was a time when youth repeatedly remade culture in a collective and spontaneous reaction to the conditions of fragmentation in which it found itself.

Going to Polytechnic in Portsmouth in 1968 I found myself organising **Arts-workshop** events with a vision of a crazed arena from which a new collective culture would emerge. The extent to which commercial culture was dismantled on such occasions was impressive and refreshing, if temporary and naïve

Then in 1971 I lived in a van for a year and a half and joined the Fluxus/Cage influenced **Scratch Orchestra**, a 50 strong group of enthusiasts who 'pooled their resources to make music.' It was here that the possibility of making profoundly beautiful and articulate events without being exclusive with respect to performers or audience, and without limiting the territory of possible interaction with the dominant culture, was proven to me. In retrospect it also felt like the beginnings of reclaiming my 'lost' working class culture and it is largely this experience which still sustains me.

Much of my time was then taken with publishing a series of books on 'basic life supports', **Survival Scrapbooks**, **Shelter**, **Food & Energy**, and a long self-organised re-training, especially in Contact Improvisation and Co counselling.

After the birth of my son in 1979 and a period of active parenting I returned to my earlier focus on visual art, finding in the newly formed **Brixton Artists Collective** a rough ground on which my oppositional and collective art practice could find space to show itself.

It was from the Brixton (Collective) Gallery that the **ART OF IMmediaCY** and **ROADWORKS** were organised. The first with Ian Sherman took the newspapers to task in a 2 week series of performances, seminars and evolving installation. The second was 'Ten artists work in public for ten days, documenting their work back in the gallery on a daily basis'. **ROAD-WORKS** rethought the relation of gallery to public space. It was also later at Brixton Gallery that **BIGOS artists of Polish origin** had their first, successful show. This is the group I had organised with the help of Kasia Januszko.

Brixton Artists Collective was formed in 1983 at about the time I was looking for a suitable door through which I could again become engaged with the visual arts. From my past experience in Portsmouth and with the Scratch Orchestra I knew that where artists organised in an open way, there the most energy and excitement of cultural flux was to be found. The Collective was fortunate in securing the marvellous three arches under the railway in Atlantic Road. The experience of collective organisation is often painful and exhausting, and here was no exception. Only those with the most resilient emotional spirit and resolute aims survived. The underlying base of power was that the more (unpaid) time you could give the gallery, the more influence you had. The open collective meetings complicated this base of power. Nevertheless these meetings were still intimidating to newcomers. But despite all the disadvantages of open collective organisation, the Brixton Gallery achieved much in its first three years and became **a unique platform for working class artists** in London. Many people, groups and communities were showing work for the first time.

The next major influence in this sequence of events was the open show organised by Glyn Banks and Hannah Vowles, **Our Wonderful Culture**, Bloomsbury, London 1985. In this show I met Edward Woodman and Ed Baxter, collaborations with each of whom were to be particularly fruitful. It was here that Karen Eliot of 'Smile' magazine met

Banks and Vowles. The loose group that emerged from this went on to make the notorious shows **Ruins of Glamour, Glamour of Ruins**, London 1986 and **Desire in Ruins**, Glasgow 1987.

Experimental art activity like this is so poorly funded and marginally presented that the artist's intention is often limited to a few moments before a very small number of people. This is the filter through which only certain ideas can rise to the privileged 'Art World' proper. The main function of this filter is to maintain and stabilise the systems of oppression, dominant ideology, status quo, standards - call it what you will. The filter is adjusted to let enough new ideas through to stimulate, but not enough to threaten.

This book chronicles selective collaborative work over the last 4 years. Each piece took considerable work and yet was seen by relatively few people. I don't think anybody saw more than 5 or 6 pieces. So by collecting the evidence and documents together, it is hoped to communicate my **overall intentions** as a working class artist and to provide a proper context in which such work may be viewed.

The book is organised into three areas which reflect the prevailing emphasis of that work. In practice, however, such hard and fast categories do not exist and many events could happily exist in the other categories as well. The first area of concern is the manner in which images **play their part in this system of oppression we suffer.** Glamour **represents the area in which human dignity is under most vicious attack. The next category,** Spontaneous Culture Now, **suggests an art practice that functions as useful culture within daily life, as rituals made appropriate for the time rather than traditional formats in which meanings are often lost or, worse, are a thin veil over exploitation. The last category suggests a new art practice which emphasises the** relation between artists **and the economic condition of artists as an essential context** within which **work should be seen. Overall the book is also an attempt to solve the documentation/ archiving/ historicising problems of performance and ephemeral work in an independent manner.**

It is not easy to cordon off the area I want to discuss in this book. Collective cultural activity defies the definitions and categories that arise from a commercial mentality. The difficulty lies mainly in choosing a viewpoint or even scenario. To be democratic? To write a book by committee? To represent one person's view as the views of all? I make no apologies for the bias of this book. Nor for the varying criteria by which each piece is selected for inclusion. Some events I organised, some I didn't. Some I took part in, some I didn't. Some work submerges individual authorship in a collective product (Holy of Holies!). In other events individual work (How bourgeois!) was put together with other work in one space to make a collective 'installation'. In such cases I might include only my individual contribution. In all cases I will present my viewpoint in favour of my own work. Anything else is fraught with complications.

Collective work is too often attacked because it is **never collective enough**. Someone is always seen to be at an advantage. Collective working exposes the hierarchies of power that exist hidden in the usual fragmented art practice. The myth-ridden longing for an ideal past 'community' jars with the aggravating and divided reality of human relations. But this 'problem' is the centre of our project. On top of this, myths of democracy in which everyone has an 'equal share' are just as bad. Then there are also myths of slavery in which everyone is expected to 'pull their weight'. From a critical point of view this sort of work refuses to submit to a linear evaluation. An anthropologist might be better equipped to analyse what's going on than an art-critic.

Stefan Szczelkun
July 1987

6

CONTEXT, TEXT, IMAGE

How oppression is mediated thru' visual culture

much general discussion
ry and Collective and
new directors were elect
the Collective: Sally A
ews, Guy Burch, Anne Dc
nwood, Andrew Hurman,
Sally Mould, Herb C
Sergy, Lester Shore,
Tony Strange, Stefan Szcz
laro and Teri Bullen.

RØADWØRKS

18 May to 8 June 1985
BRIXTON ART GALLERY

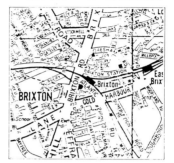

Rasheed Araeen
Marc Elmes
Mona Hatoum
John Hewitt
Kasia Januszko
Roland Miller
Carlyle Reedy
Ian Sherman
Kumiko Shimizu
Stefan Szczelkun
Gennaro Telaro

Ten artists work in public for ten days documenting the work back in the gallery on a daily basis. In addition three artists present paintings (Marc Elmes) prints (John Hewitt) drawings and photographs (Kasia Januszko) on related themes.

The daily activity will range from works on paper to performances. Through the daily cycle of meeting/action/documentation a collective character will evolve. ROADWORKS is designed to challenge conventional notions of the function of gallery space. It also aims to provide a collaborative working situation with public access to the process of making art.

A 'Closing Event' will take place on Saturday 8th June at 7pm.

17-21 Atlantic Road, London SW9 - tel. 01-733 7757 - 10 to 6 Mon. to Sat.

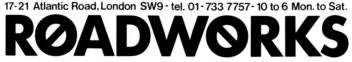

Organised by ROUTINE ART Co. — Funded by G.L.A.A.

Marc Elmes
Mona Hatoum

MONA HATOUM. TUES 21st MAY 1985

9

Ten artists work in public for ten days documenting the work back in the gallery on a daily basis. In addition three artists present paintings (Marc Elmes) prints (John Hewitt) drawings and photographs (Kasia Januszko) on related themes.

The daily activity will range from works on paper to performances. Through the daily cycle of meeting/ action/documentation a collective character will evolve. ROADWORKS is designed to challenge conventional notions of the function of gallery space. It also aims to provide a collaborative working situation with public access to the process of making art.

A 'Closing Event' will take place on Saturday 8th June at 7pm.

ad, London SW9 - tel. 01 - 733 7757 - 10

ADWOR

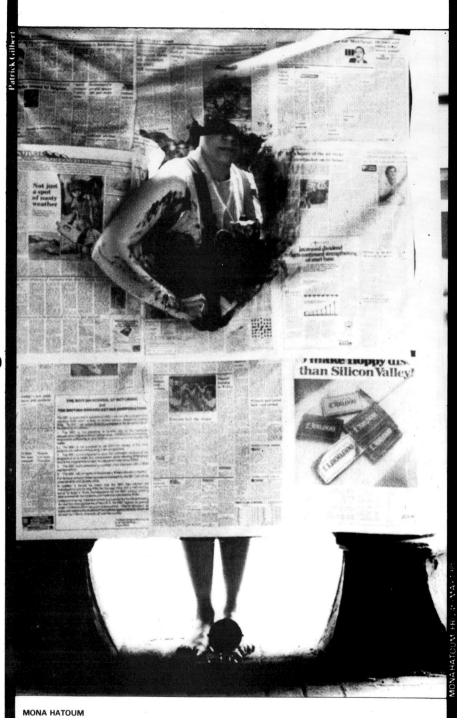

MONA HATOUM

Patrick Gilbert

FREEDOM

GENNARO TELARO

12

IAN SHERMAN

13

KASIA JANUSZKO

14

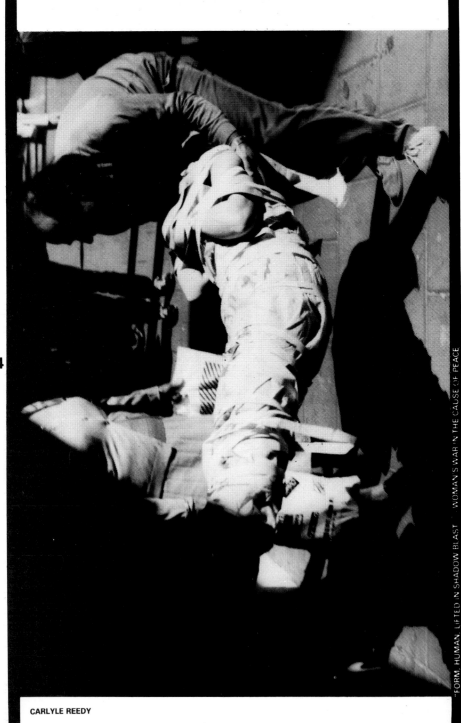

"FORM, HUMAN, LIFTED IN SHADOW BLAST" WOMAN'S WAR 'N THE CAUSE OF PEACE

CARLYLE REEDY

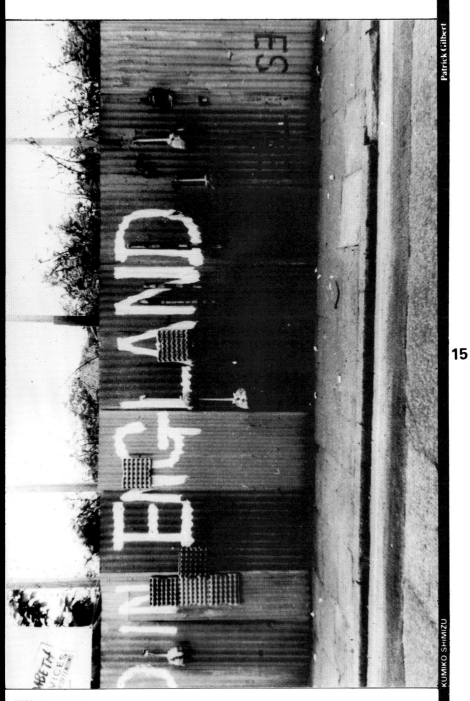

Patrick Gilbert

KUMIKO SHIMIZU

KUMIKO SHIMIZU

15

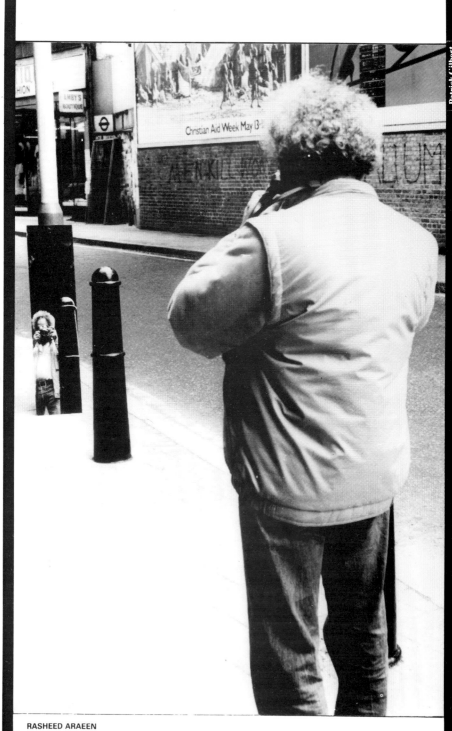

16

RASHEED ARAEEN

GENNARO TELARO:
WRITTEN ON THE GALLERY WALL: THOUGHT IS LIKE THE OCEAN, YOU CANNOT BLOCK IT, YOU CANNOT FENCE IT.
HANDOUT: IT IS THROUGH LOVE, UNDERSTANDING, SIMPLICITY, PURITY, CARE, HUMILITY AND WITH THE SURVIVAL OF THE CHILD INSIDE US THAT WE WILL ACHIEVE FREEDOM.
LET'S STOP OURSELVES RUNNING AFTER THE FALSE MYTHS CREATED BY THE SYSTEM, THEY WILL LEAD US TO DESTRUCTION.

MONA HATOUM: The aspect I found most interesting about ROADWORKS, apart from the freedom of working outside the confines of an isolating gallery environment and all that it entails, was the very different nature of the audience. The fact that the audience was basically all the other people on the street, a non specialised, chance audience experiencing casually the artists' actions while passing by, gave the work a more ephemeral, immediate and less precious character. But more important and relevant to me is the nature of the Brixton community being a predominantly Black community with which I feel a lot of affinities. I found myself in this rare situation of creating work which although personal/ autobiographical, had immediate relevance to the community of people it was addressing. I also found that I was working 'for' the people in the streets of Brixton rather than 'against' the indifferent, often hostile audiences I usually encounter. One other place where I experienced similar affinities was during my recent trip to Ireland where I was showing at the Orchard (Derry) and the Art and Research Exchange (Belfast). There was a strong feeling of mutual identification between me and the people who came to see the work...

IAN SHERMAN: I TRIED; **OUTSIDE** - TO ATTRACT ATTENTION; TO ASSUME; TO AMUSE; TO CREATE A MOMENT'S THOUGHT ABOUT - OUR SITUATION, 'HERE AND NOW'; POSSIBILITIES; TRYING; TO BREAK THROUGH THE BOUNDARIES. **INSIDE** - TO ADD SUBSTANCE TO 'EXTERNAL EVENTS'; INTERPRETATION; POSSIBLE MEANING; TANGENTS THAT BETTER DESCRIBE THE WHOLE; - MY PRESENT; MY PAST; MY ANCESTRY - MY HISTORY: - **FUTURE**. June 1985.

KUMIKO SHIMIZU: I have been walking around Brixton which cover the quite a large area, extending from Camberwell, Stockwell, Clapham Common and Herne Hill, for about 5 hours every day in pre-planned area collecting waste materials from the streets, taking photos and taping conversations with people in the areas of Brixton I toured and I have numbered the areas 1 to 4.
I spontaneously painted the materials I collected in area 1 with many colours and then made an installation on the wall in Milkwood Road behind which is the industrial development site.
I also painted the materials I collected in area 2 and 3 and made them into sculptures which I displayed in Rectory Gardens because I found this street particularly interesting.
While walking around the Brixton, I have never encountered any hostility at any time. As I walked around in such a funny way, wearing a straw hat, carrying a camera, a bag over my shoulder, a casette recorder in one hand and pushing a little trolley with a lot of rubbish on it, sometimes people laugh at me but not in a nasty way, and most of them accepted as I was. One day some builders on the top of a house were singing as they worked and when they saw me they started waving hands and laughing and called out 'Mad girl is walking' but in a friendly way not a nasty one. They sang a song for me to tape.

KASIA JANUSZKO: MY CONTRIBUTION TO *ROADWORKS* WAS A SERIES OF RELIEF PRINTS TAKEN DIRECTLY FROM THE PAVEMENT IN THE BRIXTON AREA. THE COLOUR OF PURE PREMIXED PIGMENT WHICH I SIEVE ONTO THE SURFACE IS DETERMINED BY LOCATION. I EMBOSS BLOTTING PAPER, PICKING UP A RICH IMPRESSION WHICH METAMORPHOSES INTO AN EMBLEM-LIKE IMAGE.

RASHEED ARAEEN:
Since 1972-73, when I was politically active n Brixton as a member of Black Panther Movement (BPM), I have not been directly involved in any other project here; although life in Brixton, both at political and cultural levels, remains part of my consciousness. In other words, Brixton still represents for me a poltical space, an important site of black struggle. My participation in *Roadworks* is therefore an attempt on my part to re-enter this space and without giving this space a deterministic status.
The relationship between art and politics is not simple, and the fact that I do not live in Brixton makes this relationship more difficult and complex. My relationship with Brixton is not what Gramsci calls 'organic'; but that does not mean to say that this represents a complete detachment. I may not be part of Brixton community, but I'm part of its struggle. The solution offered to this situation by political activists on the Left is to make art activity subordinate to political activity, which is based on the notion of supremacy of politics and which thus creates another system of relationship which is hierarchical and exploitative. I recognise the importance of political struggle, but at the same time it is important to question political determinism in relation to art. This work is an attempt to develop a **SPACE** of mutual interpenetration.
The work comprises of photographs of the sites which I occupied or the roads I walked during my political activity in Brixton in 1972-73 and are taken with a mirror placed in front of the camera so that the view at the back is also reflected in the photographs. The final work in the gallery comprises of these photographs as well as the copies of **BPM**'s Newsletters of 1972-73.

CARLYLE REEDY: ...I COLLECTED THOUGHTS AND PROBLEMS FROM PEOPLE IN THE NEIGHBOURHOOD IN WHICH THE GALLERY IS FOUND, FROM PEOPLE WHO CAME INTO BRIXTON ART GALLERY AND FROM PEOPLE WHO WERE PASSING DIRECTLY ON THE STREETS OUTSIDE THE GALLERY.
...EVERYWHERE I COLLECTD THOUGHTS I FOUND TWO POSITIONS: LOSTNESS AND EVASION...
...I COLLECTED PEOPLE'S PROBLEMS FAR MORE QUICKLY AND MORE EASILY THAN I WAS ABLE TO ELICIT THEIR THOUGHT AS VALUED FUNCTION IN A MOVING, CHANGING AND ACCESSIBLE PUBLIC WORK...

EXCERPTS FROM A CATALOGUE PRODUCED BY THE ARTISTS

17

ROADWORKS REPORT JUNE 1985

'ROADWORKS' an international festival of public performance with artists from Italy, Palestine, Poland, USA, Japan, Pakistan and England.

I entered 'Roadworks' on the 18th of May after nearly a year's organising, overbrimming with hopes and fears. Hopes for artists that go back to my experience at college in Portsmouth from which the slogan 'ART MUST GET OUT' originally arose nearly 20 years ago†. And fears that the idea would be spoilt by police intervention, hostile public reaction and consequent lack of will amongst the artists themselves.

As it happened, the police never interfered and apart from Ian Sherman not being 'allowed' to travel on the Underground in a cardboard box, amazing space was allowed us by the policemen that attended events. This was helped by a public who, faced with unexpected actions of the oddest variety, showed great tolerance, interest, amusement - but rarely any hostility and never physical aggression. Although the artists each had their own lives and problems to deal with and were not the tight, homogeneous, disciplined unit I had dreamed of (!), everybody worked very hard to produce results.

The only part of the brief described on the poster that was not fully realised was '...through daily meeting... a collective character will evolve.' However, there was much collaboration, discussion and exchange of ideas, so a collective character probably would have been possible if a framework had been made for it.

Another thing that was different to what I had imagined and planned for was the use of a key map to guide visitors to the time and place of actions. This was too much of an additional burden on the

artists, who were fully involved in just realising their own ideas and document- ation. Patrick finally made a nice visual with string and photos, but it was never the precise tool that I had hoped for, and some visitors were frustrated by the lack of an accurate timetable.

Some other minor difficulties of organ- isation would have been much improved if we had had the services of a paid administrator and technical assistant. We were aiming to achieve such a lot in the three weeks: ten daily actions - evolving wall documentation - video - xerox post catalogue - final night performance - publicity (a big problem as Brixton is definitely "off circuit" for most reviewers) - administration - staffing the gallery. Ridiculous really on just £100 each! (£1000 from G.L.A.A.). The actions didn't seem to suffer in quality but the documentation on the walls and the published catalogue suffered in some cases from financial and other deprivations. The build-up to the last night performance was also painfully hurried and tense, although the evening itself went off well. (Apart from the rough cut video being mysteriously incompatible with our 22-inch monitor).

But overall, considering the whole thing was very ambitious and run on a shoe string, I think it went very well, producing a wealth of material and interconnections. It demonstrated that the art gallery can serve wider functions than the showing of 'finished works': it can serve the public environment directly and bring this con- text back into the gallery to provide a lively situation in which artists and the public can communicate 'directly'. Intuitively I think the question of context effects art practice on a more profound level, but this is impossible to demonstrate without much wider feedback from a prolonged pro- gramme of such activity. (June 1985)

whys + wherefores

1. To make uncompromising connections between performance and conventional artwork. Pulling conventional objects into the real world of artist at work and process, making visible the context from which they arise, and giving performance the base, continuity and support to give it lasting substance and stop it being ephemeralised.

2. The presence of the artist for feedback and questioning. The personal and general context from which the work is created becomes visible. Being in the world and present makes the artist more responsive and accountable (without being slavish). People's reactions and what they understand are important if we are interested in a broad based, rather than the present elitist, art culture. The artist becomes a part of everyday life.

3. Technicals are demystified rather than being *USED* to create awe-full mystery. Techniques may be shared and learnt. The mystique of the artist may be seen as a real person like everyone, screwed up, lost, wanting to be loved and accepted, afraid. Not to be deified, rarified or made out as the seer she may not be, any more than any of us who can use our imagination to read the random patterns left by tealeaves.

4. A new role is suggested for the Gallery. Rather than being a pristine showcase of precious *objets d'art* set within an almost hermetic art world from which refined objects occasionally gain popularity (Constable, Moore) it becomes a base which directs people to the artist at work and to the actual effects of the artist on the environment and society. The issue of the process takes precedent over monetary aesthetic values. The artist may be seen to be working and playing daily.

5. The gallery is not just a neutral space, the Gallery is itself an image, a frame, a cultural viewpoint. It is locked into a set of cultural ideas which most people will unconsciously take on board as soon as they enter therein. Unconsciously formed expectation, preconceptions and conventions. Pretty on the wall, nice clean lines, fashionably stylish, technical control, a frissance of polemic and a dash of trendy socialist innuendo. Fits comfortably, survives, don't rock the boat, grant doesn't miss a beat, administrator achieves ambition, &c. If we want change, the whole cultural package must be shook up, rock 'n rolled, twisted and shouted at. Rethought out (and about). We must drive the galleries we control into non-violent confrontation with the monetary system. Only this confrontation will throw up the real contradictions and bring down the illusion of liberal freedoms.

We must address the world first. Let the Art establishment pretensions stumble over their own absurdities in an effort to keep up. As they must if artists move out into society together.

6. An arena for artists to work collectively or in parallel. To have dialogue, see each other's problems, share ideas, support each other, stimulate each other. It works against the isolation of most artists (at work) where low fees often lead to the logic of working solo.

7. Many artists have of course been working out in direct response to the environment since art began but it's time we forwarded this unrecognised activity as the *MAIN SUBSTANCE OF OUR ART* (of which museum pieces may be just the synoptic conclusions).

"Roadworks" at Brixton Art Gallery

Guy Brett

"Roadworks," initiated by the artist Stefan Szczelkun and organised collectively, took place over three weeks in the streets of Brixton. Inside the Brixton Gallery (Atlantic Road), which acted as a base, the walls gradually came to life as each artist compiled a personal record of their live events. The calibre of the artists involved, a generally high level of social awareness expressed through very different sensibilities, an imaginative basic concept, made this an event of great interest. General backup and presentation may not have been up to the level of individual contributions, but I felt I learnt a great deal from this show, both as creative vitality and as a social barometer.

I'd been alerted by the fact that this event was not based on a "theme," or on one genre of art, or the presentation of finished objects, but on the creative potential of "meetings." First, between artists. Stefan Szczelkun is an Anglo-Polish artist who has worked in performance for many years, recently with the English artist Ian Sherman. Kasia Jasuszko, who experimented with print-making directly on the street in this show, is also Polish. Rasheed Araeen comes originally from Pakistan, Mona Hatoum from a Palestinian family in Lebanon, Kumiko Shimizu from Japan, Gennaro Telaro from Caserta in Italy and Carlyle Reedy from America: all have lived and worked in Britain for long periods. The second meeting was between artists and people, which took place un-announced in the streets, parks, railway stations. And the third meeting was between artists and a particular place, which is best described not with pretended objectivity by myself but through the perceptions of the individual artists which were attuned to different aspects of a complex reality: Brixton. For the potential richness of these meetings was both that the artists had something in common: a perspective as "outsiders" (out-

side the British establishment, outside the gallery, outside conventional notions of an artist's activity) – and significant differences of life-experience.

This was a time for spontar experiment, lively and fresh ideas one saw Brixton primarily in black struggle (as Rashee Hatoum, did for exa of modern socie Gennaro T where w sig

the uved in that Van Gogh re then fields, nis present life with were deliberately eccen- tory itself resides in crevices es above the busy everyday e, somehow left-over, trapped . . .

The whole show made one think of boundaries, borderlines, and to see other metaphors in that threshold between the "gallery" and the "world outside." To step outside the gallery as an artist is to step into another reality, governed by different codes and possibilities. But to grasp the relationship seems as important today as it is to grasp the relationship between the small-scale goings-on of a locality and global events, or between the viewpoint of the specialist and that of people in general. Even the crazy, perhaps forlorn, and vulnerable aspects of the events in "Roadworks" seemed to stress the importance of such "meetings" in an increasingly sealed-off and "hard" culture.

24

25

THE ORIGINAL WORKS WERE PHOTOGRAPHICALLY
REDUCED TO A3 AND THEN XEROX REDUCED TO A4
TO BECOME PART OF A BOOKLET DISCUSSING
'ROADWORKS' FROM THE ORGANISERS' POINT OF
VIEW.

ART OF IMmediaCY with Ian Sherman, Andrea Stokes & Judith Green: Brixton Gallery, Nov 1983

DESCRIPTION: For 12 days we took the daily papers and each day worked on them in the gallery. The main technique was to whitewash large areas of the paper leaving key images or words intact. The white spaces were then opened up for us to write our personal comments or 'news'. These were then hung around the stripped brick railway arch in profusion.

In addition Ian and I did seven evening performances based on that day's news or our attitudes to the papers generally (see reviews). On evenings when we did no performance, speakers came in to lead discussions: 'Bad News' with Duncan Campbell, 'Images of women in media' with Jennifer Chibnall of Woman's Media Action Group and 'Racism in Media' with Sonia & Dorothea from Black Women's Group.

The last day of the exhibition was marked by a strike which halted all newspaper production.

IS A JOKE
THE VOICE OF BRI...

Tuesday November 15 1983 . 18p . TV Pages 18 and 19

Cruise is here

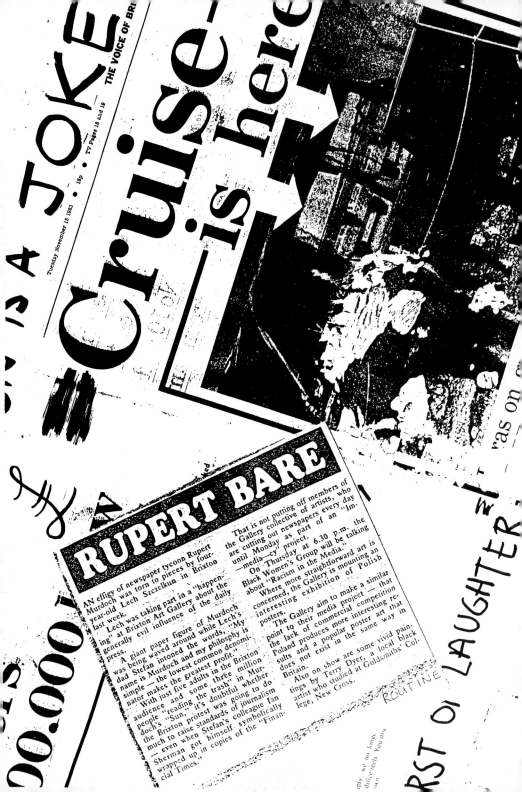

AN

RUPERT BARE

AN effigy of newspaper tycoon Rupert Murdoch was torn to pieces by four-year-old Lech Szczelkun in Brixton last week.

Lech was taking part in a "happening" at Brixton Art Gallery about the generally evil influence of the daily press.

A giant paper figure of Murdoch was being waved around while Lech's dad Stefan intoned the words, "My name is Murdoch and my philosphy is simple — the lowest common denominator makes the greatest profit."

With just five adults in the Brixton audience and some three million people "reading the trash" in Murdoch's "Sun," it's doubtful whether the Brixton protest was going to do much to raise standards of journalism — even when Stefan's colleague Ian Sherman got himself symbolically wrapped up in copies of the "Financial Times."

That is not putting off members of the Gallery collective of artists, who are cutting out newspapers every day until Monday as part of an "Imedia cy" project.

On Thursday at 6.30 p.m. the Black Women's Group will be talking about "Racism in the Media."

Where more straightforward art is concerned, the Gallery is mounting an interesting exhibition of Polish posters.

The Gallery aim to make a similar point to their media project — that the lack of commercial competition in Poland produces more interesting results and a popular poster art that does not exist in the same way in Britain.

Also on show are some vivid paintings by Terry Dyer, a local black artist who studied at Goldsmiths' College, New Cross.

RST OF LAUGHTER

ROUTINE

00.000

...ply, we no longe...
...difice reels You mu...

PERFECTION

As consumers we are transported into a world of attractive drama. We enter the new world of illusion and identify with the fascist dream of perfection.

The main mechanisms of oppression of the U.S. ruling class are mediated through the images **of glamour and the** text **of newsprint. That is why our text on** glamour **is in the image of a** newspaper.

34

★ ★ ★

BYPASS CONTROL installation and 'newspaper' with Ed Baxter.
DIY gallery, Elephant & Castle 'The Business of Desire' (April 1986).
Description: A window frame mounted on the wall. Seedy net curtains. The view is dominated by a giant newspaper. A strip of blue sky and green landscape survive like the drawings that children do when they first go to school. High above the window four god heads preside. A bald statement of the hierarchies of glamour. Below the window scattered shards of ceramic remind us there is a history to be reconstructed. Copies of a tabloid sized version of BYPASS CONTROL are available to visitors to the gallery. I include a few cuttings to give you an idea.

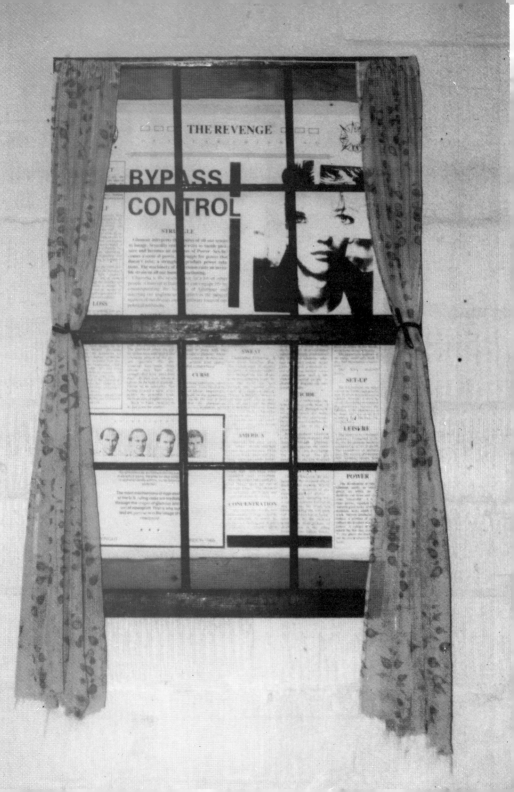

OBJECT

The glamourous are the objective proof of the idea of wealth separated from the actual production of wealth. Glamour objectifies the abstraction from reality. Nothing is so glamourous as taking hard drugs.

SELF

The whole separate from the parts; disconnected: In glamour's ideology of self, the body is commoditised and separated from the "self".

. Apart from its arbitrary nature, random Glamour may be bought by close association with the glamourous object. A dull man with a Porsche becomes suddenly 'interesting'. A little penis is 'exciting' only if it is the key to Luxury or Style.

In Beirut in the 1960s people would follow the dictates of *Vogue* and have "summer" and "winter" sets of clothes even though the weather did not necessitate a change. In fact, there was *no change*: instead, a rigid imposition of the rules of monetary culture.

LOSS

There is nothing less glamourous than looking after kids. The company of children brings up profound irritation for most adults. It is too reminiscent of their own early suffering and lost vitality. Reminiscent of loss. Childhood as loss, one's "lost youth" – because Adult means 'In the Labour Market'. As adults provide the framework for children's activity, so this unbearable occluded pain provides the straitjacket within which adults live and from which 'childcare' operates. Of course at the same time, in opposition to this, parents do dearly love their children. In this ambivalent atmosphere glamour thrives.

A glamourous woman will find mothering an exceptionally irritating task.

BYPASS CONTROL

STRUGGLE

Glamour interprets the desires of all our senses as Image. Sexuality ceases to exist as tactile pleasure and becomes an analogue of Power. Sex becomes a scene of power, a struggle for power that doesn't exist: a struggle to produce power relations. The machinery of oppression casts an invisible strain on all our human functioning.

Charisma is the resemblance to a lot of other people. Glamour is banal. We can engage life by counterpointing the banality of Glamour and asserting our unglamourous selves as the subject matters of our desires and the primary focus of our political ambitions.

PASSIVE

We never see the heads on which the jackboots of glamour stand. We never even see the boots. The usual trick is to hint at a grim and seedy past. This explains everything. The past from which the glamourous have emerged is the laborious present of the passive spectator. The glamourous have risen above labour: they have done enough; they have "paid their dues". In their eyes, labour is taboo. In the light of glamour, labour seems unworthy. Not having to work is ideal: it ennobles the powerful, lends them an aura of righteousness.

Back to Eden. Nothing to do but name the animals.

COMPENSATION

Glamour is a loan from Nature which was never intended to be repaid. A bit like the soil. Nature compensates. The laws of nature and of human institutions are conflated. We are held in place with the scotch tape of glamour. An invisible economy. A short-cut.

A vacation from oppression, but a return ticket.

CURSE

Glamour represents effortless success. To be freed of the curse of labour. Immortality. The death of the glamourous never means the end of their life. For the glamourous, death is ever-imminent, never

actualised. N them deep-f dried like th Their fate is t and this can b fore they die. life of a celeb happened to –

SW

Christophe new world. that sounds s freedom. A seen through mour in a com way the w through the saints in a m Thomas A Be sale sixty year der, so much have weighed alive; Elvis Pr sale by the phi ker had the sh wrung out eve day a commod

AME

America. T

asts an invisi-
g.

lot of other
ngage life by
lamour and
s the subject
y focus of our

NSATION

a loan from Na-
s never intended
A bit like the soil.
nsates. The laws
d of human in-
conflated. We
place with the
glamour. An in-
ny. A short-cut.
I from oppres-
urn ticket.

RSE

epresents effort-
o be freed of the
ur. Immortality.
the glamourous
he end of their
ie glamourous,
imminent, never

actualised. Memory keeps them deep-frozen, freeze-dried like their dead pets. Their fate is to be forgotten, and this can happen even before they die. What is the half-life of a celebrity? Whatever happened to – ?

SWEAT

Christopher Colombus. A new world. Freedom. Boy, that sounds swell. A singular freedom. A singular reality, seen through the lens of gla-mour in a comatose State, the way the world was seen through the stained glass saints in a medieval church. Thomas A Beckett's blood on sale sixty years after his mur-der, so much sold he must have weighed 150 stone when alive; Elvis Presley's sweat for sale by the phial. Colonel Par-ker had the sheets and towels wrung out every night. Every day a commodity.

AMERICA

America. The great union of white beauty-and-light power was proclaimed. From now on black slaves will pro-duce sugar and white beauty shall rule. The diet shall be all white and good. White bread, white milk, with white sugar sprinkled over everything. Sweetness and light shall pre-vail. Never again the dirt of manual labour. The children of sweetness and beauty and light will charm the world.

CONCENTRATION

The cinema film was the first mass carrier of images capable of dominating the world. Its centre was Hollywood. A con-centration of cultural capital

and human talent never seen before. This intense concen-tration of capital made certain things inevitable, as vested in-terests sought to maintain their grip...

Glamour is concerned with images; it is a result of mass media images in a consumer culture. It simply externalises the alienated relations inhe-rent in a money system. As we cannot imagine a modern so-cial life without money, so we cannot imagine such a life without beautiful people to identify and disguise our own complex frailty.

SUICIDE

Glamour as technology: the transformation of the body, of the biological, through tech-nology. Between the body-builders and the annorexics, the locally suicidal milling be-neath the gaze of the gla-mourous.

Applied glamour: Glamour is the conflation of power and decay. Through glamour, capitalism opposes the immi-nence of its own dissolution. The living dead. The gla-mourous are the raw material of the capitalist media.

PRIVACY

Glamour concerns the sus-pension of the moment where death and life coincide. Where are the key moments of gla-mour production? Dallas – with Kennedy slumping for-ward in the limosine forever in slow motion, his fresh red blood speckling the soft pink suit and pill-box hat of Jackie, surrounded by the civilised world. The most private of deaths, seen in the living rooms of one billion lovers.

MASK

The blandness of the basic beauty patterns offered by Glamour also symbolises a sort of global unity. By wearing the mask of desire in our minds, we become as one in beauty.

The oppressive qualities of the image could only work if they had their human counter-parts.

The Stars. Heavenly bodies.

SET-UP

The Glamourous are those who fit the bill through genetic luck. Perfection is produced at random, because it must be evenly distributed throughout the population, because the function of the glamourous is to make the rest of us feel worthless, ugly. The Fuzz. The Faceless ones.

LEISURE

The desire to be consumed. "Leisure." Consumed in de-sire for the glamour machine, consumed so as not to go off. The immilence of annihila-tion. The totality of consump-tion. Glamour means being controlled and desiring to be controlled. To be put in its power.

POWER

The devaluation of labour: Glamour posits an internal power on which the gla-mourous can draw and so be-come "successful". A myste-rious power, signified by the 'natural good looks' of the gla-mourous, looks which bypass work. Success produced from nature, a product of culture; culture the product of nature's failure. A culture of scarcity which the few may overcome. To rise above the inadequate: but the rise produces the inade-quacy.

ON 1986.

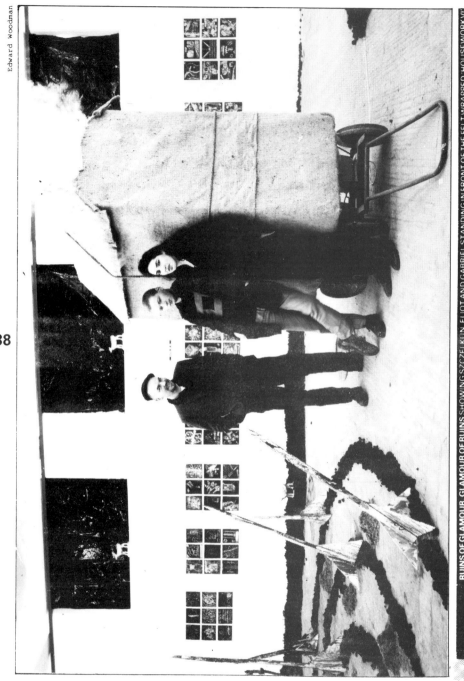

38

RUINS OF GLAMOUR, GLAMOUR OF RUINS SHOWING SZCZELKUN, ELIOT AND GABRIEL STANDING IN FRONT OF THE FELT WRAPPED 'HOUSEWORK V'

ruins of glamour glamour of ruins

AN INSTALLATION OF WORK BY GLYN BANKS/HANNAH VOWLES, ED BAXTER, SIMON DICKASON, KAREN ELIOT, GABRIEL, RICK GIBSON, ANDY HOPTON, TOM McGLYNN, STEFAN SZCZELKUN

Perhaps the first thing to be said about the installation *Ruins of Glamour/Glamour of Ruins* is that it is meant overall to be 'an experience which trans-lates slowly but undoubtedly into ever-increasing discomfort. From the aggressive bright light which blinds the entering spectator (who, at that moment, empath-izes with the prisoner dodging search-lights) to the image of the topless Page Three-like girl, we are made to feel both vulnerable and culpable. The intention of the artists, it seems, is to encourage us to reexamine ideas of glamour and to quest-ion its importance in our lives.

The work is never simplistic: aside from endeavouring to shock us into, at best, good behaviour, and at least, reassess-ment, it offers intermediary levels of parody and dilemma. It is political and thus contentious, particularly with the image of the young trendy shooting heroin into his veins or when the symbols of authority in the form of glossy, class-indicative art brochures lay, half-burnt, amongst the rubble of coke. There is not a clear-cut opposition between glamour and ruins: they are intricately, and suffocatingly, bound up with each other.

Symbolically, it is the half-clad female figure which our attention is focussed upon. From a burning building whose ruins now form part of the landscape, she escapes to nature. She seems to be neither in control of her present state nor in control of her destiny. With her gold heels amidst the coke and hair, hanging like *bildung*, carelessly on a nail, there is certainly allusion to the nude as a sacrificial object. Yet, all she can manage to evoke within us is coldness, distance. Are we not also responsible for the absence of emotion we feel here?

The gyre with its missile-like project-ions, the photo-copied rubbings which flirt with fantasy, the shamanistic toy soldier striking a militaristic pose against a sentimentalised background, and finally that fascinating, repulsive and depressing mountain of old teabags all seem to be a neat collection of fetishes which are no longer accompanied by their rituals. The hard, cold substance remains and the heart, which lent content to the form, is long gone. If at times the work is inaccessible, then it is because glamour is just that.

And this is what *Ruins of Glamour/ Glamour of Ruins* is all about. Glamour is our own creation, yet like some hip and ugly frankenstein, it has deadened our senses and succeeded in controlling us. The only question which remains must deal with the issue of apprehending and exposing social phenomena. Undoubtedly the artists are here concerned with objectivity and social reality but surely, as they as well as the audience are partic-ipants, are they not also to be held accountable for their complicity in per-petuating myths of glamour? Perhaps they have not gone far enough.

Oku Ekun Goll

OKU EKUN GOLL IS A LIBERIAN ANTHROPLOGIST RECENTLY RETUREND FROM THE SUDAN

39

the ruins of glamour

Our idols, the stars. Parts played by ordinary people selected for their 'natural good looks' which we are meant to emulate, adore, imitate, worship, identify & sympathise with; and judge ourselves against. From which process the majority of us emerge with the status of worms.
Samantha Fox: 'I want your body.'

There may have been a time when there was a functional basis for the judgment of one body as 'better', more useful than another. But the judgment itself was always the affirmation of privileges already gained and consolidated, a differentiation or ordering of human beings. The appeal to beauty is an appeal to sympathise with the dead - or rather, with the bosses of the dead. There is no worthwhile basis for the evaluation of one type of appearance, one way of appearing, more than another. Nor can the singular evaluation be legitimately held up as a social standard by which we are all to judge ourselves. The classification of human beings on the basis of 'good looks' allows oppression in its commodity formats to reach deeper into our lives than ever before in the past. As technology has given us the tools to overcome any real scarcity, the present system of exploitation requires that above all we should take full individual repsonsibility for oppressing ourselves and each other.

The system of social stratification on the basis of appearance developed out from the old occult sites of power, replacing heaven, ritual, penance, cosmic glory, communion of saints, and so forth, transposing them through the global media technology &

decentralised multi-national corporate imperialism of the USA.

Dirt is associated with disease, poverty and degradation - and in the classist myth it characterizes work. Wear a white collar and you've taken the first step out & up. Production, whether it is mining coal or giving birth, is a painful dirty business that 'the cultured' don't indulge in. To imitate the upper classes, to become like them, it is important to be clean, respectable. The beautiful models represent the democratisation of the ruling classes, to which we may all aspire. They populate a landscape of goodness, while we hate ourselves for our imperfections.

The rigidity with which the values of glamour encapsulate us is remarkable. They are installed at a very young age as a promise of a future of perfection (self/relationship with others/mate). Good babies smile and sleep. Bad babies moan and scowl and whine and wail. Good infants are passive. Bad infants are naughty. To be glamourous is desirable because it is to receive adoring attention from millions of enraptured fans. Attention that would have been useful when you were a baby, when your 'self' was being produced, - but which has no actual function now, as an adult.

Orphans from the storm, the glamourous were never born, they produced themselves from the quagmire of labour. Swamp creatures, emerging from the gigantic sump of the past. The cultural denial of the experience of birth, of the social antidote to fear of individual mortality.

As the USA conquered the new world in the nineteenth century so it forged its identity in the Hollywood of the 1920s and '30s, in the cowboy films of the 30s, 40s, 50s - a daily dose of death in the wild west softened us up for the global newsreal violence that began to pour into every living room in stark black & white. At the same time, helpless media junkies watched as every spectre of human relations resurrected itself in glorious technicolour. In the red corner, the big-boobed baby-faced healthy wealthy blonde chicks, in the blue the dark-haired pale anorexic junkie Twiglets. In the newsagent window:

DEATH BEAUTY SEEKS VIOLENCE. The sound of smashing glass echoes, cheering. Nelson. A death to inspire. Sunlight through the portholes. You are so weak you can hardly hold your head up, so Hardy holds it for you. A sublime silence fills the space as everyone present is transfixed by the beauty of this never-to-be repeated moment of history. Through your weak fluttering eyelids, you see a painter manically at work in the shadows of the bulwarks. You beckon weakly. Hardy leans forward, offers his ear, you ask for water, etc, etc. Up above, the decks are strewn with bodies ripped asunder, scenes of dying sailors untended, unwatched, ugly. A sailor with his foot blown off drags himself across the deck. You turn away and throw up overboard. This is the death available to all, the Woolworths, Levi jeans, Coca Cola death. The Kaiser up to your knees in mud death, the Xmas Island to Chernobyl fall to pieces death. The death of ordinary people is a matter for statisitics, not history.

Star quality is a by-product of a situation of fake scarcity. The glamorous prove the 'natural' reality of scarcity: they are so few and far between, 'there is not enough to go round.' Complementary to the definition of nature as a system of necessary inadequacy is the definition of the technological realm **41** as essentially destructive & requiring checks. Left to their own devices, the machines would take over - after all, they can think for themselves now, can't they? This has produced, like a self-fulfilling prophecy, the tried and tested tools for our destruction. Technology threatening us on one hand, Nature still predatory on the other - the androids, robots, ants and rats, all closing in on the fortress - all making a grab for the screaming heroine - of course we have to keep them in line. And the human race? Well, what is the heroine for?

'The only criticism you can have of Mrs Thatcher is that she has such good legs.' Glamour is presented as a 'natural' occurence with little cause for complaint except jealousy.
'I do find it exciting to see glamourous violence - the sort where no one gets hurt and it's all exploding high technology. That's the sort of violence we are expressing' (Sigue Sigue Sputnik).
The productive but fictional *crisis* is grounded in our sense of separation from nature & technology. And at the same time, in that this separation is one of struggle to domin-

ate, they express a myth of mastery in a culture devoid of a ground of solid meaning. Technology is immortal. By trying to internalise it, to bring in inside...

The star as mirror. The mirror presents a body without orifices, sealed like the Pharaonic mummies, an impenetrable surface. Noli me tangere. How to insert meaning into this, how to penetrate the screen? Just a fumbling, frustration. The deferment of the arrival of the seventh cavalry of sense, never to rout the new model army.

False promises: the new model of human beauty espouses not only a purity of soul but a perfection of complexion and surface. The sanitised images suggest the absence of microbes on a being that transcends the grimy humiliations endured by the workforce.

The first visual pattern we recognize when we are born becomes the means for the invasion of arbitrary value. In the first face that looked at us we search for a validation for our existence and self-worth. Frozen needs for that early look get translated in to a desire to be looked at by the face of status, power & beauty in adulthood.

It is possible that the *gaze* that typifies glamour exploits the baby's need to latch onto a recognizable human face. The face provides a ground of value at a very early age. Frozen needs for that early look are translated in adults into a desire to be looked at by a face expressive of status, power, or beauty. The 20th century is almost completely retinal (Duchamp).

The face which provides the narcissistic illusion of a ground of meaning. Beauty and death. In the shadow of destructive technology, which we seem unable to exorcise, we swagger towards oblivion, caked in animal fat. Technology: first, extra-biological survival: through our artefacts we can memetically reproduce our 'selves'; but what a pain - that this *stuff* should survive us! Wasn't its whole meaning just that?! How to contain it?...

In a recent tv programme about the selection of the daily *Star Bird*, the Star's editor rejectd a woman for this honour because she was not relaxed enough and *because she showed fear.* Light, radiant, attractive, confident of their status and social advantages, the glamourous strive to disguise the banality of their programme. Just as the human antics of the saints diverted attention from the fact that heaven was empty.

The most negative act of criticism of oppression can be celebrated as resistance. Oppression is the fundamental devaluation of humans. Celebration is anything that oppposes this. Glamour is the religion of the person reduced to a facade. A preparation for life in the bunker. The only power of glamour resides in its parasitical use of own powers, our ability to influence the events of our life, through the domination of the way we see each other. By occupying the territory between such polarized roles as artist/ scientist, activity/ product, gallery/ public realm, elite/ popular, production/ ritual, friend/ enemy, by creating channels into which such polarities, diverted, will collapse by their own dead weight, by transgressing these constrictive limitations, we can deny the validity of separation. To intervene or oppose may bring about recuperation or attract anihilation.

I can see a great canvas, improbably enormous, its surface burnt to a cinder. Spectacularly fragile flakes of fresh carbon curl from this surface - the negation of the glossy surface - my name signed in its bottom right hand corner in mauve neon. Rich people standing before it go into convulsions which can only be brought under control by writing cheques. The artist is commissioned. The work is installed in a specially built lobby - 'unfortunately' the whole house catches fire. The patrons lap it up: carbon as milk, art as renewal, money the destroyer. Soon the totality of expression catches on - buildings are designed to look as if they have been firebombed, smoke curling out from a charred corner as the building is opened by princesses. On the street, fashion veers in pursuit - young men and women wear their dark grey tweed suits with one shoulder burned off...

A curious idea prevails: that life is not 'enough'...

Stefan Szczelkun / Ed Baxter 1986

42

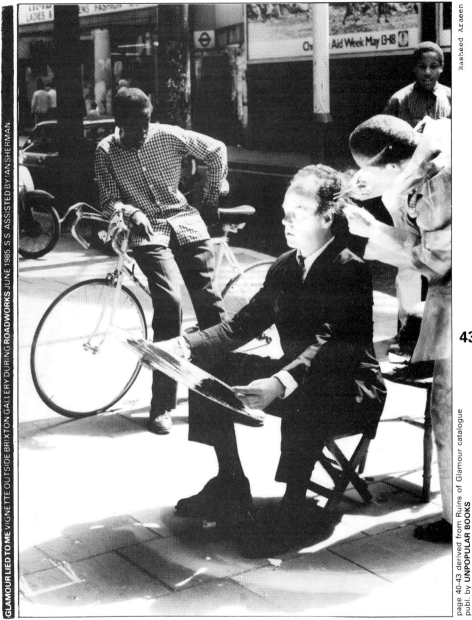

GLAMOUR LIED TO ME VIGNETTE OUTSIDE BRIXTON GALLERY DURING ROADWORKS JUNE 1985 S.S. ASSISTED BY IAN SHERMAN.

Rasheed Araeen

43

page 40-43 derived from Ruins of Glamour catalogue
publ. by UNPOPULAR BOOKS

But the *Ruins of Glamour* . . . in fact attempts something very different from Sixties' political action-art. Like much of the art that has been influenced by the debates between marxists and post-structuralists — Victor Burgin's work is perhaps the most obvious benchmark in this area — this exhibition seeks to engage with a set of contemporary discourses that cross over the boundaries between words and images, criticism and practice, nature and culture, gender and class, pleasure and social structures of power. An implicit assumption of the exhibitors seems to be that theoretical reflection is in itself a kind of political practice. Going around the exhibition was therefore very much like attending a seminar in which the discussion was conducted by means of visual conundrums and images that evoked responses and then negated them. Generally, the installations succeeded in making me rethink the ways in which glamorous images from both popular and high culture determine my subjective experience, especially my experience of those objects of desire that have ruled so much of my behaviour.

At a simple level, this work can be read as saying that the glamorous objects of desire presented to us by the media distort both our perceptions of nature and of each other. With their power to stimulate and paralyse through spurious promises of a 'natural' perfection, these images can destroy us. Glamour, in a phrase, creates ruins.

I should say, overall, this was a refreshing and optimistic exhibition. Beyond the mountains of oily trivia in the West End galleries, here at least was a group of cultural workers trying to deal with politics, and with the relation of their own medium to physical and ideological violence.

□

Mo Dobson, NEW STATESMAN, 2-1-87.

THE SEQUEL to last year's 'Our Wonderful Culture : Art in Ruins,' in the crypt of St George's Bloomsbury, is another doom-laden installation, this time in the Chisenhale Studios (64 Chisenhale Road, E3), a good place for a St Valentine's Day massacre.

Unnerved by spotlights, moth-balls and drifts of smoke in the binliner blackout, those entering Ruins of Glamour, Glamour of Ruins, stumble across abandoned catalogues embedded in coke. Glamour here is not a pretty sight, more an 'oppressive reification,' as Karen Eliot, one of the nine artists involved, puts it. And so we have a pin-up of Rambo on high and images of Samantha Fox superimposed on scenes of desolation dating back to as long ago as 1916. Cheap music lulls one into the 'Oh What a Lovely War' mood.

Parked, like one of Monty's caravans, in the centre of the dereliction, is a small, felt-covered wagon such as would have been used by Joseph Beuys playing Mother Courage. Next to it is a coke spiral with punches of sand scattered here and there and stakes sticking up at angles. In the gloom it is hard to make out what purpose is served, but the implications are clear. Golden calves, enlarged from farmyard models, are the key : beefcake to be worshipped before slaughter.

So 'Ruins of Glamour' is a sort of threnody with 'Heroin is the Opiate of the People' on the one hand and a mass of used teabags on the other. The scene is vaguely reminiscent of the Underworld in Cocteau's 'Orphee.' Those demonstrating against 'oppressive reification' are themselves perpetrators of inverted glamour : the glamour of Beuys materials and improvised retaliation. Bits of wood bristling with nails lie on the spiral of smokeless fuel.

William Feaver, OBSERVER, 14-12-86.

SELECTED REVIEWS : EXCERPTS.

The show might be called "seven sets in search of a (political) scenario," except that they mustn't search too hard or else it might become "art" and invert its own perverse premises. Instead, a sort of scorched-art policy is followed: the ubiquitous advance of capitalism's simu-culture of spectacle, glamour, and false consciousness is to be countered by strategic withdrawal across a nihilistic terrain of irony, absurdity, and cultural blasphemy in which all values and all images alike are put to the torch. Yet the curious thing about all art-anti-art warfare is that art has a way of always, if not winning, then surviving. If I say that Ed Baxter, Simon Dickason, and Andy Hoptons' *Seasonal Desires* — the spiral of coke and cruise-stakes that dominates the room – achieves an "imagehood" that contradicts its own semio-clasm (although art-historically it seems a rather obvious case of Richard Long, meets Anselm Kiefer), I'm not sure that I'm not doing them a disservice in terms of their own aims. Likewise, Tom McGlynn's frieze of golden toy calves. Best of all, or worst, was Szczelkun's eighty-one drawing frieze of rubbings from surfaces within his house, *The Nature Of Objects*.

"Bad drawing at its best" as he puts it, they are in one sense a literal record of consumer objects, in a further sense an ironic comment on their reduction to spectacular image as commodities; but finally, surely, and in contradiction to the presumptive pessimism of the show, they are a testament to the liberating victory of imagination over the banal fetishes of ascendent normality.

Brian Hatton, ARTSCRIBE, March 1987.

44

Now that the Spectacle, that is a society reduced to appearances by the commodity, has invaded every surface of the body and from there to almost every human relationship and certainly every relationship mediated through commodity/media that has an aspiration to power, every previous territory of class oppression is reduced under the one umbrella. Glamour.

Now liberal whites feel disgust for blacks not directly for their colour but because they are not glamourous. Glamorous blacks are conscripted to participate in the positively discriminatory tokenism that masquerades as anti-racism. Equal opportunities for women as long as they have good enough legs. It's trendy to be working class as long as you clean behind your ears and speak distinctly. Disability is OK as long as we don't see it. Sexually abused children make the news but the adult sexual distress, perpetuated in every commodity image, is never discussed.

In this way glamour is permeating all areas of oppression and unifying them. The new stylish leftists liberate themselves from obsolete forms of oppression only to fall under the glittering yoke of glamour. To shake off the unification of all separations requires a convulsion beginning in our own bodies, from our own histories, and emanating out through society in the destruction of commodity consciousness. This social earthquake, in which the accumulated fear which is the glue of class society will find its solvent, will shake the new world to pieces.
12.12.86.

This text was part of a collective assemblage event at Chisenhale in East London called *GLAMOUR LIED TO ME*. It included performances by Andy, Vikki Moorhouse, Gabrielle, Rick Gibson, and *DON KEY WORK*; a film by Ayoka Chenzira called *HAIRPIECE*, a film for nappy headed people; a playground song by Lily Double called 'My name is Diana Dors'; a reworking of Sam Fox's 'I want your body' by *DON KEY WORK*; video by Phil Jeck. And the participation and help of many other people.
(See Karen Eliot's review.)

45

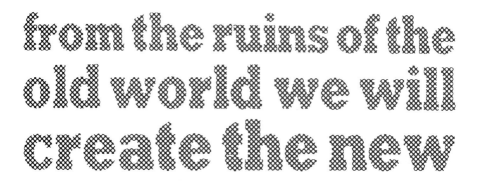

from the ruins of the old world we will create the new

Stefan Szczelkun's recent stint as 'performance artist in residence' at Chisenhale Dance Space and Studios constituted one of the most concerted assaults on the reifications of art, politics and life since Gustav Metzger's "Destruction in Art Symposium" of 1966. Interpreting his brief in the widest possible sense Szczelkun demonstrated the possibilities for using the 'concept' of performance as a base for integrating 'apparently' disparate activities.

Two performances, "Housework" and "Glamour lied to me", formed an anchor point from which other events spiralled out. These included a group installation in the Chisenhale Gallery and "Postal Art Communion" which took place in various E3 post offices on the day the 1986 Christmas stamps were issued.

"Housework" (performed 14/11/86) was concerned with the politics and oppressions of everyday life. The performance actually began outside. Szczelkun pulled a wooden wendy house around the streets of Bow, stopping now and then and nailing discarded materials to its archetypal facade. The spoiled innocence of the wendy house and slides of the artist's mother 'performing' housework were put to use in an indoor event. Against this tableau Szczelkun staged a theatrical deconstruction of the myths that reinforce misery and oppression in daily life.

"Glamour Lied To Me" (performed 12/12/86 and 13/12/86) emphasised the necessity of collective action in the war against all spectacular mediations. As such the event was structured on the lines of a 'post-modern' workers' council. The 'leadership' role of the performers was both task orientated and rotated. Indeed audience 'participation' was not simply solicited, the council style situation actually allowed the audience to take over and dictate the unfolding of events. This manifested itself in two very different forms on the two evenings of the performance. On the Friday, when the audience was 'led' back into the Dance Space after 'witnessing' a street event, it collectively refused to sit on the chairs that had been placed down the length of the dance floor. Instead the collective body occupied the seats at the back of the hall which had not been intended as the viewing area for the next scheduled performance. On the Saturday, A... S..., who had paid to attend as a member of the audience, proved to be far more theatrical in 'real life' than his worthy but dull performance art had intimated. During the "TV eye object" action he seized temporary control of the task orientated leadership by urinating from the Chisenhale fire escape and screaming at Edward Woodman to photograph these antics rather than continuing to document the street performance.

These events, and documentation of other activities (such as the *"PHOTO DAY DUETS"*) displayed during Szczelkun's stint as one of Chisenhale's performance artists in residence, demonstrate that artists can reject the egotistical role of star, and forge a radical practice based on collective action.

Karen Eliot.

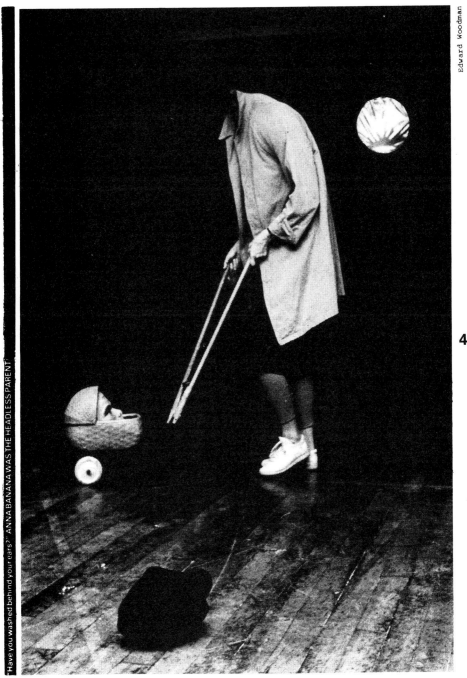

'Have you washed behind your ears?' ANNA BANANA WAS THE HEADLESS PARENT.'

47

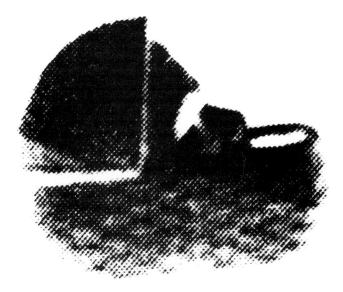

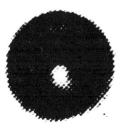

SECTION 2

SPONTANEOUS CULTURE NOW!

Working class history, social art, ritual & time

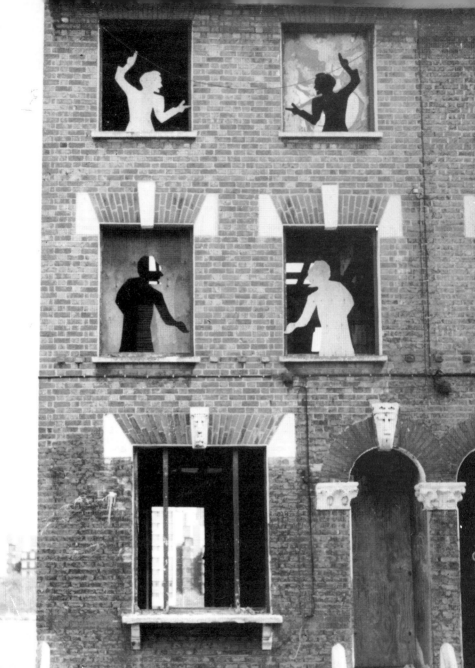

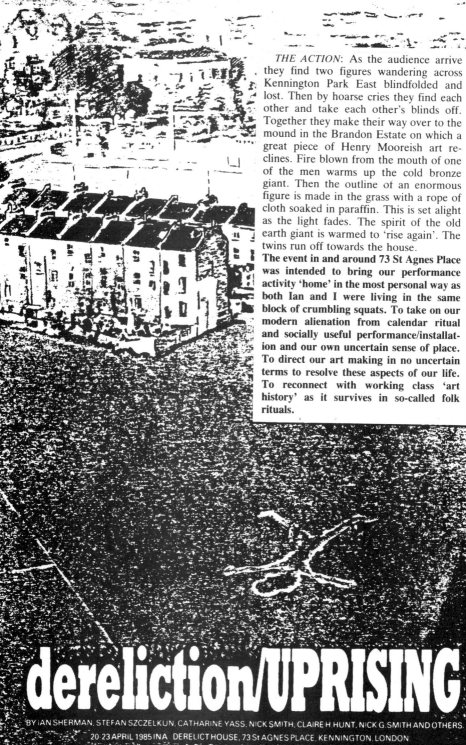

THE ACTION: As the audience arrive they find two figures wandering across Kennington Park East blindfolded and lost. Then by hoarse cries they find each other and take each other's blinds off. Together they make their way over to the mound in the Brandon Estate on which a great piece of Henry Mooreish art reclines. Fire blown from the mouth of one of the men warms up the cold bronze giant. Then the outline of an enormous figure is made in the grass with a rope of cloth soaked in paraffin. This is set alight as the light fades. The spirit of the old earth giant is warmed to 'rise again'. The twins run off towards the house.

The event in and around 73 St Agnes Place was intended to bring our performance activity 'home' in the most personal way as both Ian and I were living in the same block of crumbling squats. To take on our modern alienation from calendar ritual and socially useful performance/installation and our own uncertain sense of place. To direct our art making in no uncertain terms to resolve these aspects of our life. To reconnect with working class 'art history' as it survives in so-called folk rituals.

dereliction/UPRISING

BY IAN SHERMAN, STEFAN SZCZELKUN, CATHARINE YASS, NICK SMITH, CLAIRE H HUNT, NICK G SMITH AND OTHERS.
20-23 APRIL 1985 IN A DERELICT HOUSE, 73 St AGNES PLACE, KENNINGTON, LONDON

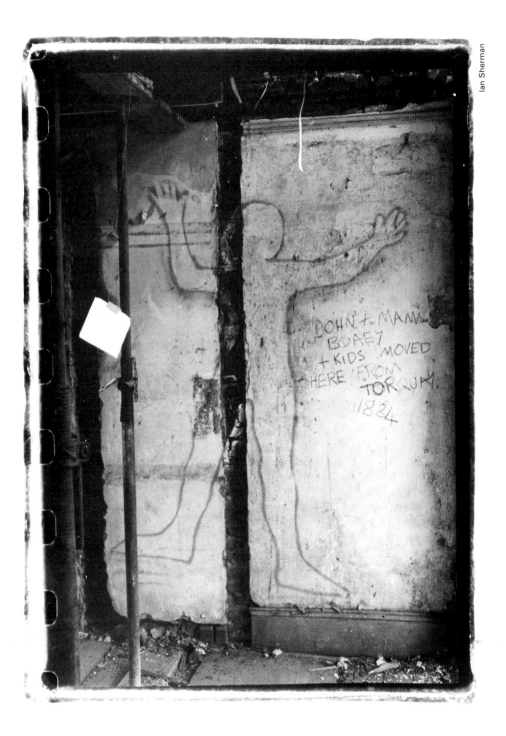

DEATH COMA DERELICTION CRYOGENIC SLEEP DREAM
SENSE OF PLACE HOMEMAKING WELCOME RESUSCITATION
THE STIRRING OF THE GIANT SPIRIT WITHIN US
CATALYSING LATENT POWER BY MAGIC
LEVITATION LIGHTENING GIANT HOPES ARISE

MMMMMMMMMUUUUUUUUUUUUUUUUUMMMMMMMMM
Why'd they want to kill us 7 times over?
Go back to the clay where you come from
I ate you
AY ATE YOW ORL

Soon we won't hear her no more
then there'l only be you or your shadow to be heard by me
Soon they won't see her no more
then there'l only be you or your shadow to be seen by me
soon they won't smell her no more
then there'l only be you or your shadow to be smelt by me
Soon they won't taste her no more
then there'l only be you or your shadow to be kissed by me
Soon they won't touch her no more
then there'l only be you or your shadow to be touched by me
Soon she won't warm us no more
then there'l only be you or your shadow to warm me.

Audience is ushered in to the upper-ground floor of No.73 which is a prepared environment in which they are reminded of the previous inhabitants of this 100 year old now derelict house. Suddenly a crashing of chains from below the floor heralds the opening of a trap door from which the twins emerge, only to climb up a rope ladder and break through the paper ceiling and disappear into the space above. (Apart from this area of paper ceiling the floors above have joists but no floors or ceilings.)

From then on the action all happens above the audience's head. Performers move in the upperspaces by swinging on ropes lit only with small torches. There is a spring cleaning report on tape. Arms break through the paper ceiling with messages and images of elephants with little wings. Pink feathers drift down from the heights. Film of a primeval face flickers onto white painted slatting. The performers above become increasingly airborne... spiraling lights. An increasing sense of panic leads into sudden bright lights and a take off scenario with the performers spreadeagled above the audience as if in free fall.

FROM DEEP WITHIN OUR DERELICT HEARTS

dereliction/UPRISING

20.21.22.25th APRIL
AT 8.30 pm

(NORTH)

GABLE

FRONT (WEST)

RAISING THE ROOF TO THE STARS

DISCARDING THE CEILING

BOARDED

RUIN

NO GLASS OR FRAMES

RENDERED

DEMOLITION OF LETHARGY

DERELICT STRUCTURES ABANDONED

10M

SMALL TREE

BACK GARDEN

RUBBISH

SM

WAKING UP GIANT HOPES

Just as the earliest Christians often built their churches on the sites of stone circles and christianised pagan feast times, changing names but not dates, images but not sites; so we subvert existing customs. Separating ideology from life functions.

Even a more spontaneous culture which we aspire to, requires its fix on the topology of history, requires its rhythmic place within larger circles of time. Ancient metaphor and myth have been discredited by science or used to breath life into empty commodities but they are still tools required by the human mind to give abstract knowledge of identity and place imaginative life. Without the mythic dimension given to important events of life by ritual, the mind is limited in its perception of the values of abstract wholes.

Our surface appearance is of battle-weary zombies. To realise our underlying giant nature we need to be able to use metaphor... to make it an element of production. Rationality is not enough to motivate the human mind to overcome its encasement in the image.

April 1984: revised entirely April 1987.

three wise men

CITIZENS BEWARE!
Beware the energy thieves.
In our midst,
In every aspect of our lives,
their agents operate.
(We are talking of secrets. Draw near.)
Voices murmur in the ear
- a frequency you can't quite hear -
the words are coming loud and clear
but only the ones they want you to hear.
The Whisperer walks beside you.

And we all unaware
carry out our lives in patterns and routines,
comfortable screens to shield us from the glare.
And the Whisperer always there,
stealing our lives
moment by moment
while we are sadly absent.

Do any of you really think you know what you are doing?
Why are you tapping your fingers?
Why are you clenching your jaw?
Is it because you want to? Or are you acting under orders?
The cynical among you are wondering why you came.
I'll tell you:
Our agents got to you in time.
Now all good men take heed
In the hour of greatest need. A LEADER HAS ARISEN!

Mortimer Ribbons 1984

Three Wise Men: Performed ZAP CLUB 27th November 1984.

The three wise men - Stefan Szczelkun; Ian Sherman; Mortimer Ribbons
Messiahs - *Celsius:* Kasia Januszko; *William Blake:* Caroline Holbrooke; *Engels (voice on tape):* Mine Kaylan.
Photographs by Zap photographer Richard.

We open with Mort's rap from microphone stage centre. Ian and Stefan are each following stars that are dangling from the end of sticks they are holding out in front of them.

IDENTIFICATION: We gather on stage, each reading a definition of wisdom. Then linking arms in a circle facing out we career around wildly.

ORIENTATION: Ceremonial immersion of Stefan's star into a fish tank of sea water. We decide to begin our journey together on a humble donkey. We take it in turns to ride piggy-back with a cardboard donkey's head. We barge roughly through the audience (people have moved chairs into the route we have prepared). Struggle.

SCIENCE: The route is circuitous and back on stage we discover Celsius, complete with large thermometer, who we assume to be a Prophet or the Messiah. But before we can really begin adoration, we get a rude 'stuff it' sign from Celsius and are given scientific navigation instruments which we try out in awkward and clownish fashion.

INDUSTRY: There is then a sound track of heavy manufacture and Celsius produces boats (one each) which we get into and set off through fairly rough seas in search of the true Messiah. Ian goes up the wrong channel for a while but ultimately we discover, under an illuminated dust sheet at the back of the auditorium, William Blake; who as soon as we uncover him begins reading his poetry, which dazzles us. We bear our prize back to the stage where we set him up in a shrine (a chair surrounded by a circle of candles). Blake continues to read whilst we adore him.

IDEALISM versus MATERIALISM: Suddenly our homage is interrupted by a germanic voice from a loudspeaker. It is Engels, reading an excerpt from the communist manifesto which derides the utopian communism of Fourier and Owen, etc. The presence of Engels is represented by a life size xerox pasted onto a cardboard box.

- We then get confused by the interruption of Engels and begin to argue amongst ourselves. (Thinking poses section omitted).

ORACLE: We decide to consult the oracle which is the fish tank full of sea water. Ian puts his head under for an interminable period, followed by Stefan for a shorter period. Mort then (impromptu) invites the audience to try their hand (or head) in TV Quiz style. A member of the audience steps up and to the delight of the audience immerses his head. The audience counts up to 30...

SWEEP A WAY FORWARD (or LEFT IN DOUBT): We then brush our exit out through the audience and out the back door onto the beach. I crawl on hands and knees with a huge broom, Mort follows sprinkling gold dust and placing pebbles. Ian is meant to light these with rubber cement but it all gets in a mess and only a few get lit.

We exit. Thunderous applause, etc.

57

3 Wise Men: Notes on Working Methods
This was a collective event based largely on a style developed by Szczelkun and Sherman in their previous *Art of Immediacy* at Brixton Gallery, December 1983 and *Dereliction Uprising,* 1984 (influenced by Mort's experience with Crystal Theatre). The characters of Celsius, Blake and Engels were derived by chance. (Their birthdays fall across the 2 days of the performance, i.e. across midnight). They become a 'reading' upon which we project our own hopes and fears in a process the same as "child's" play.

An intellectual political critique monitors this 'free' intuitive activity and may censor or promote as necessary.

Simple, rough, accessible images are sought. Although initially crude (like Pantomime), subtleties may be woven in.

Framework developed over 2 or 3 evenings and individual research. Construction in the day prior to night of performance.

58

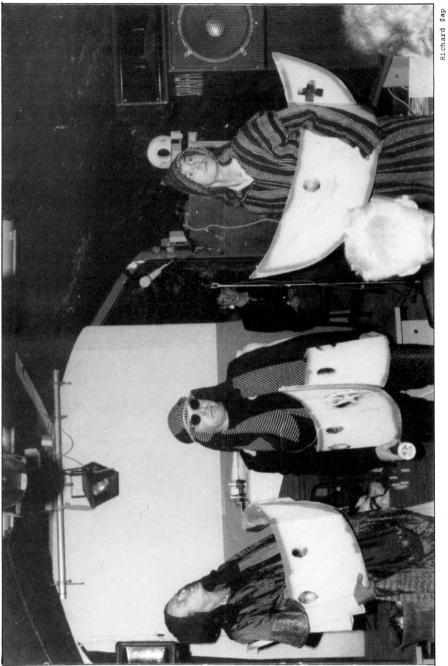

59

60

anus ritual for the longest night

Long ago before time became linear. And before people followed
the shortest line between birth and death, as they do now. When
time was cyclical and peoples perception of time passing was felt
as a *pulsation*. And the only writing was magic signs and picture
grams.

Then, on the longest night of the year people revered the anus.
They thought of their bodies as temples to the Gods of the Universe,
who made visible the creative, expansive principles of the universe.
To them the principle of renewal was the crucial principle. Parts of
the body which exemplified this ability to produce to create
were held sacred and ritually endorsed.

The prime producer was the ANUS from which stools appear magically
and fall to earth and nourish all things. Shit, earth, mud the
substance from which God initially created life. The sacred sign
of the anus was written ╪ or ╪ or A
being a pictogram of the rectal sphincter. This
sign was intoned as "Asssssssss" quiet, sibilant,
respectful.

Other prime products were semen from balls (and
perhaps milk from breasts) with sign 3 or B or B
sound BbBbBbBbBb . . And the baby from the
cunt with sign (Pictogram of womb.) ◯ or < or C
sound COOOOOeeeee (still used on arriving at a
friends home.)

Around these signs and sounds the ritual of holy self love were made.
Now in a world turned upside down.these sacred words have
become curses. So when angry we degrade these most holy and primal
parts of our own bodies.

And further the symbolic meaning of ╪ was equality; for whether
we are queens or kings, bosses or slaves, whether we eat at the
Savoy or Joe's cafe we all shit the same wonderful substance.
And this represented the fundamental social principle.

reprinted from 'Our Wonderful Culture' magazine
produced at London College of Printing from material
collected by Armar.

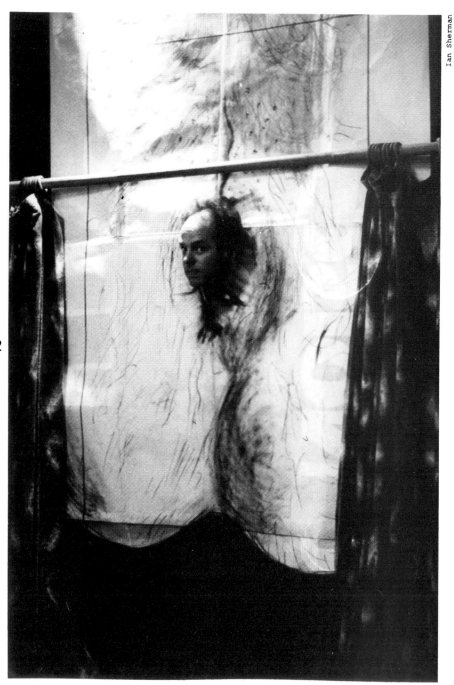

62

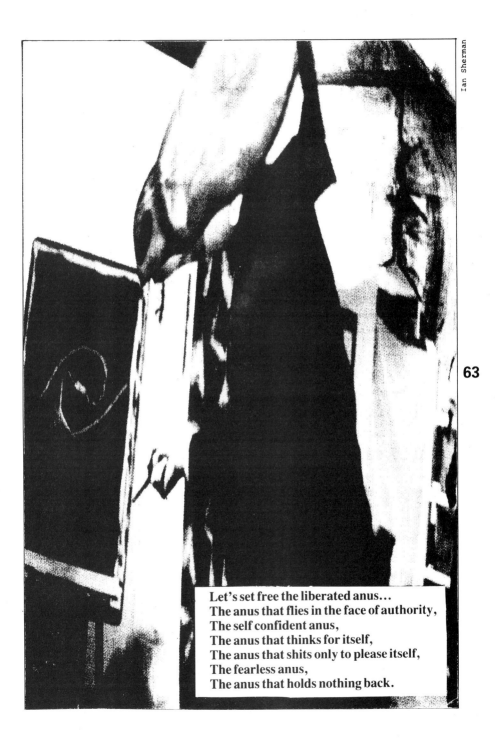

Ian Sherman

63

Let's set free the liberated anus...
The anus that flies in the face of authority,
The self confident anus,
The anus that thinks for itself,
The anus that shits only to please itself,
The fearless anus,
The anus that holds nothing back.

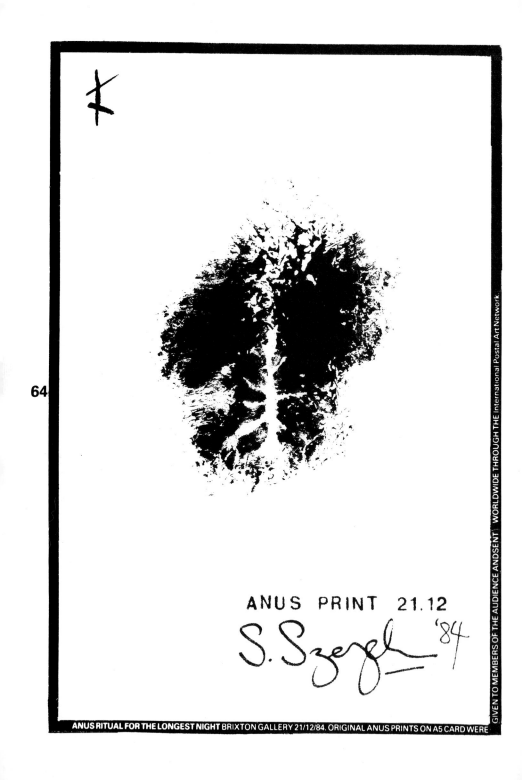

64

ANUS PRINT 21.12

S. Szegh '84

GIVEN TO MEMBERS OF THE AUDIENCE AND SENT WORLDWIDE THROUGH THE International Postal Art Network

ANUS RITUAL FOR THE LONGEST NIGHT BRIXTON GALLERY 21/12/84. ORIGINAL ANUS PRINTS ON A5 CARD WERE

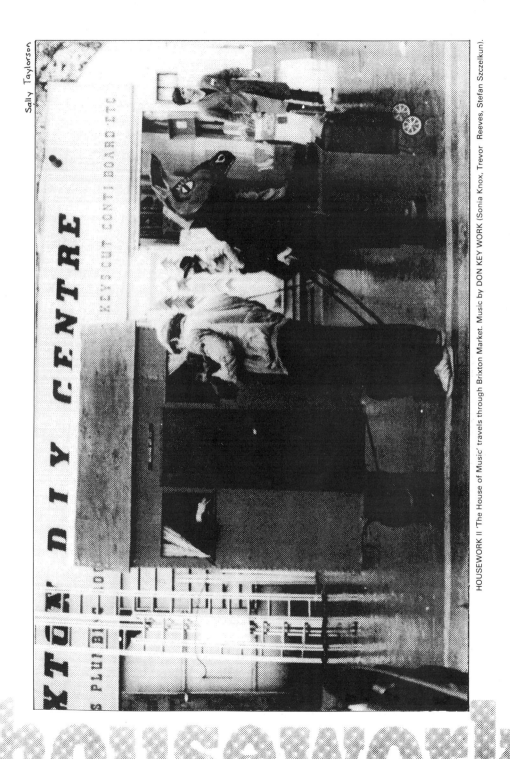

Sally Taylorson

HOUSEWORK II 'The House of Music' travels through Brixton Market. Music by DON KEY WORK (Sonia Knox, Trevor Reeves, Stefan Szczelkun).

babes in the wood

PERFORMANCE ART PANTOMIME: Performed Chisenhale, LONDON E3, 21 & 22 February 1985 in an attempt to find a collective structure by which various performers (both theatrical and art trained) could work together and also relate to working class traditions as well as fine art histories.

The pantomime format seemed an ideal vehicle. Popular pantomime is derived from several sources: the two I refer to here are Music Hall and ancient 'folk' rituals. Music Hall derived from urban working class 'free and easys' within the public houses in which people would just get up and do a 'turn'.

The Music Hall formalised this spontaneous culture into a cabaret sequence of the most talented performers. The panto incorporates this into a loose mythic structure and is of course a calendar event, being a version of the pagan mid-winter carnival. The loose structure allows everyone to fit in their own turns and can accommodate almost anything. At the same time the mythic story which runs through the anarchic whole gives the show a deeper resonance.

We chose *Babes in the Wood* which we subtitled 'New Innocents Lost & Found in the Urban Jungle'. There was only £100 budget to pay all the costs. We had three sets: a nursery, a castle (the stony wall of which ran right across the performance space) and a mythical wood (consisting of a lorry load of large tree branches set up and hidden behind the castle wall and extending to the very back of the space.) For continuity we had a *NARRATOR*, played by Mortimer Ribbons ex of Crystal Theatre, who also doubled as a fairy and godmother. His/her metamorphic and insubstantial nature does not instill trust and yet is insufficiently controlled to escape the clutches of the Evil Baron...

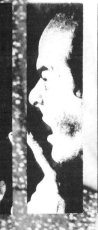

The **EVIL BARON** played by Stefan Szczelkun is power mad. The stereotype oppressor who appears to care nothing for other humans and everything for his own agrandissment.

And yet he admits to the audience to feeling lonely: "I am driven to these deeds by what has been done to me... monsters lurk in the depths of my heart... cajolling me... Sometimes they crawl up from their caverns in the distant past and take me over... " etc.

He needs the Jester and yet cannot resist his power as employer to use her and yet never can quite enjoy the benefit of her production. Their relationship is ambivalent, ambiguous and contradictory. Pregnant with all the inertia and tensions of unstable class power relationships.

The *JESTER* (Mary Susan Yankovitch) works for the Baron and sometimes sympathises with him ("Poor bloke he does his best..").

The Jester always sees both sides of an argument and ridicules rigid positions and postures wherever they appear. But she is unable to hold a strong view and is easily swayed by persuasion. Underlying her ability to get a laugh out of any situation, no matter how drastic, is the classic weakness and sadness of the clown.

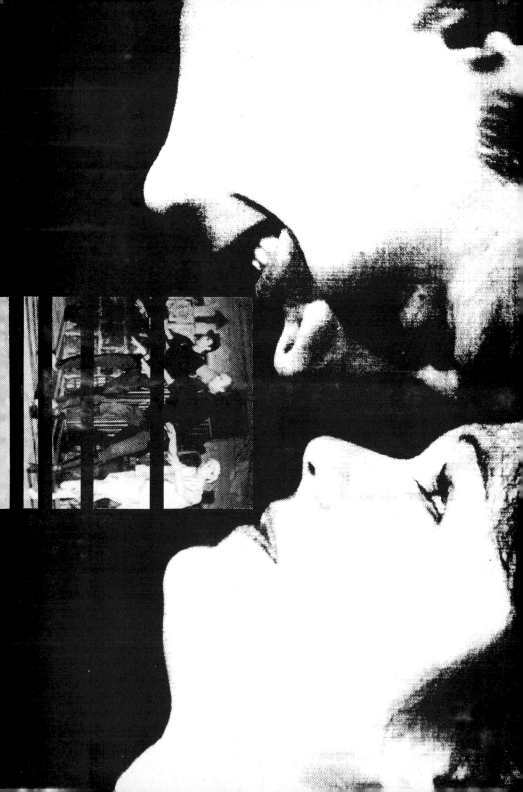

The *BABES* (Caroline Holbrooke and Ian Sherman) are innocence and the primal victims. They are also the mythic twins of mid-winter ritual. Identical, dynamic, androgynous, telepathic, awesome, etc. They are also the modern orphans, space age Dr Banardos aware of how their condition is caused by society rather than their own 'failure', by the oppression of young people and the artificial construction of 'childhood'. They are determined to use the mythical figures of modern media to their own best advantage, linking them to the (sub-conscious) tradition in dream time and play.

They have a mysterious inheritance coming to them, and it is their uncle the Baron's attempt to divert the inheritance into his own pocket by having them killed that is the slender thread of storyline. The inheritance is reckoned to carry great powers of 'rebirth' and 'reemergence' which they intend to share with all and so threaten the power base of the Baron.

The *TREE* (Ian Hinchcliffe) is nature beyond human powers of imagination. Connected, ancient, intransigent, heartless, bountiful, vulnerable. Completely outside human morals and philosophy. Of life essentially, but beyond human life. The King of plants on whom we are totally dependent. Who we ceaselessly exploit but never comprehend. The tree slow, profound, static... completely fearless and in touch with the rhythms of the cosmos and, in this case, with a very droll sense of humour.

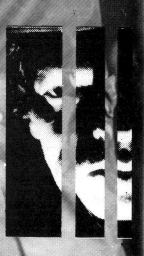

The *HERO, RESCUER, GREEN MAN* (Giles Collins) is an enigmatic character who appears as required, a presence connecting us to the power of nature (*TREE*). Existing in tune with nature, outside human affairs but watching them, maybe an alter ego of the fairy (whose task it is to interpret between humans) but more 'real,' less camp; hermit, sage, teacher of principles. Gives the young innocents the key to human nature and irrationality.

BABES IN THE WOOD (CHISENHALE)

'A coffee table fable for those who wish to eat cake' (according to the programme) was obviously taken literally by the audience who at the end of this piece only very reluctantly left, laughing and giggling in their seats in gentle rebellion until (I do not lie) they were plied with all the consumable props, i.e. the cakes — and, having eaten their way through several tins of fairy cakes only then felt they had done justice to the show and it was time to go. A surprising conclusion to this surprising post-modern pantomime — based very loosely on 'Babes in the Wood' but more a series of sketches many of which are essentially vehicles for solo performances.

Despite an awkward start of up-tempo music hall pastiche interspersed by the very mordant Jester (Mary Susan Yankovitch), the narrative gathered momentum like a roller coaster which at the peak of its climb flew straight into mid air with moments of pure over-the-top lunacy rejoining the plot after some brilliant pieces of fantasy. From the very minimal to the very hammy, the cast combines a group of people from both 'straight' theatre and performance who have first worked together as a group in this show.

The deadpan Jester challenges the outrageous and very wicked Baron (Stefan Szczelkun). The gormless 'babes' (Caroline Holbrook and Ian Sherman) occasionally zap and crackle. There is an exquisite 'Night in the Forest' tableau with mythical birds and beasts set to eldritch music. 'Tree,' also 'faithful retainer' (Ian Hinchcliffe) shakes the narrative wildly off course with a seamless piece of solo performance poetry and wordplay before joining Jester and Butler (the man of many disguises, Giles Collins) in the dungeon. An Asgardian Fairy (Mortimer Ribbons), looking like Thor in a dirty raincoat also loses his directions, this time up the M1, and therefore neglects to save the 'Babes,' who now have to find themselves and release the other prisoners from Baron Stefan. Children screeched, adults refused to leave.

These artists are redefining the limits of pantomime with its traditional characters and classic themes of the mummers' plays combined with music hall slap and tickle. This 'post-art' Babes re-writes the set pieces, interrupting the inexorable flow to a well known and comfortable climax and; moving in new directions, challenges the audiences' willingness to believe in fairy tales. ■

SUE WOLFF

review from PERFORMANCE MAGAZINE

marking time

BONNINGTON SQUARE ART FESTIVAL FOR PEACE

"VISUAL ART IS BASICALLY A METHOD OF MARKING TIME"

*The marking of time through the day and year and our sense
of position/place on the planet surface has through the
permeation of media into culture gradually become
commoditised. A week now goes by in a flickering of images
in the time it would take a day to go by in 1955 (I was
seven then). Commerce pervades all transactions and the day
turns with the desensitising and disempowering ritual of
the six o'clock news. The year turns on the orgy of commerce
that christmas has become. In the mass of commercial images
and possible purchases we become shadows of our true selves.
We lose our grip on present time and our lives slip away
through our fingers. We become disorientated and feel we
don't belong. By making a
mercurial art house that could move around Bonnington Square
as if it were a huge clock face, stopping to visit, meet and
give offerings at regular hourly intervals, I wanted to
symbolise the latent links in the community and the strength
of gift to weld these into a unity that gives a human
framework or society for our lives. I gave each house an 8"
cake box with objects symbolising the time in reality
(o'clock) and allegorically (month) and orientation (compass
reading from the centre of the square). They also include
edibles, cake (silver) and chocolate (gold) for sustenance.
I briefly explained the whole scheme to each person, asked
them to pose with me for a photograph by my house and asked
if they had anything surplus to their requirements in their
real house for my art house. Everyone gave me something and
these became visible decorations on the facade of my house.
I started at 1 pm and ended at 12 midnight. This was one of
the most satisfying events I have done. It worked as a
reflection of its intentions in giving me a sense of place
and useful function as artist within a community.*

75

ROUTINE ART CO

3RD NOVEMBER 1985

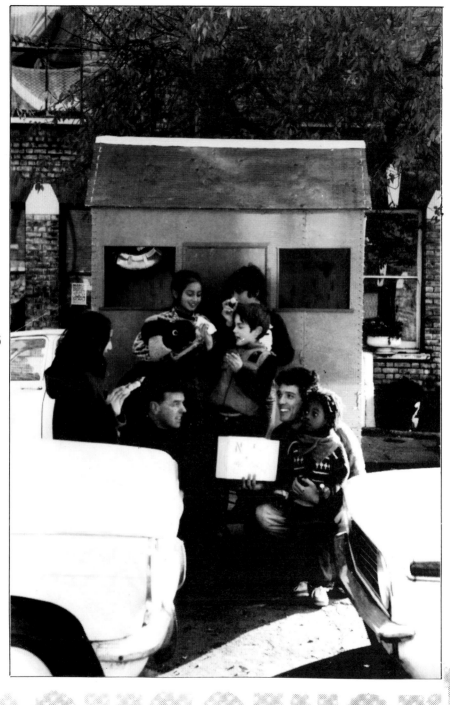

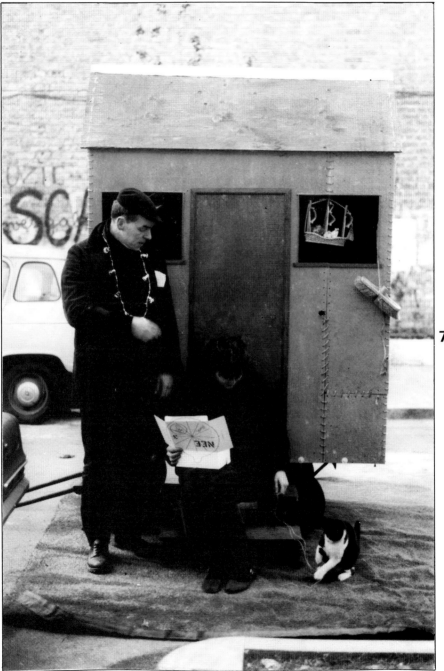

ACTUAL TIME OF DAY PM	LIST OF GIFTS FOR MY HOUSE	ALLEGORICAL TIME OF YEAR	MY BOXES TO THEM (REMEMBERED AFTERWARDS)	ORIENTATION ACTUAL AND ALLEGORICAL
1	ORANGE BROOM HEAD	JANUARY	MAFIA MONEY, SPONGE	NORTH
2	WICKER SAILING BOAT	FEBRUARY	BROKEN TOY CLOCK + ELEPHANTS	NNE
3	WATER FOR MY BUCKET + SPRIG OF HEATHER	MARCH	FRAGMENT OF UNION JACK, BAKED BEANS, YACHTING PENCIL SHARPENER	NE
4	CUTTING FROM WINDOW BOX	APRIL	SHOWERS AND TEARS	EAST
5	SPICES (NUTMEG + CINNAMON) FROM A PARTY SHE WAS GIVING	MAY	SILK FLOWERS (TABLE DECORATIONS)	SE
6	JAVIERS LATIN AMERICAN ENVELOPE	JUNE	RUBBER DOLLY + FEATHER, PLASTIC RIBBONS	SSE
7	A MULTICOLOURED BALLOON	JULY	COWBOY CARRIER BAG?	SOUTH
8	DRIED FLOWERS	AUGUST	CATAPULT, GREEN PLASTIC APPLE	SSW
9	BLACK SILK PURSE WITH SEQUINS	SEPTEMBER	BIRD MASK + MONSTER NEST	SWW
10	CANDLES WITH LACE	OCTOBER	RED WEDGE + GOLD MONEY	WEST
11	CARNATIONS IN A COKE BOTTLE	NOVEMBER	MATCHES, PARTY POOPER	NWW
12	DRIVING VAN + RUNNING CAFE (BEN)	DECEMBER	PHOTO OFFICE PARTY, INSTANT LIFE, TATTY FATHER CHRISTMAS	

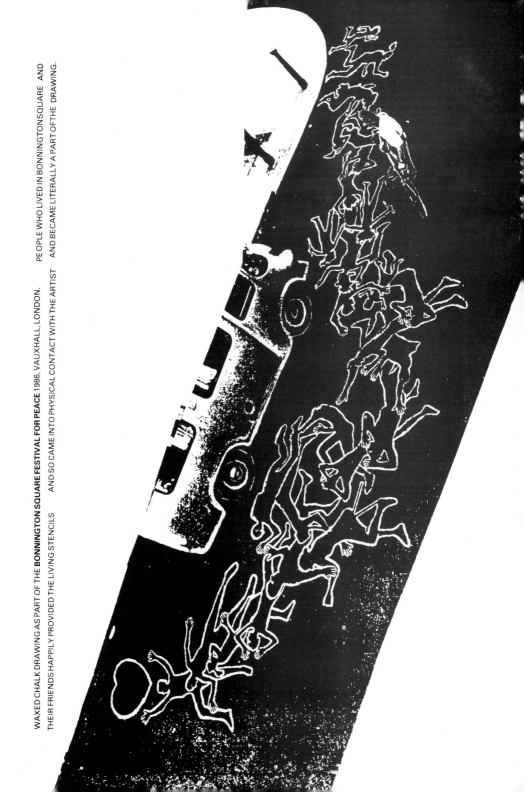

WAXED CHALK DRAWING AS PART OF THE **BONNINGTON SQUARE FESTIVAL FOR PEACE** 1986, VAUXHALL, LONDON. PEOPLE WHO LIVED IN BONNINGTON SQUARE AND THEIR FRIENDS HAPPILY PROVIDED THE LIVING STENCILS AND SO CAME INTO PHYSICAL CONTACT WITH THE ARTIST AND BECAME LITERALLY A PART OF THE DRAWING.

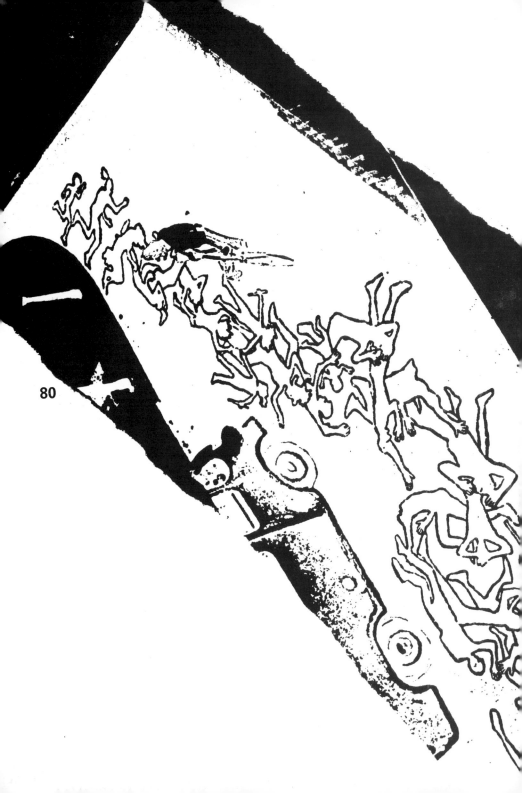

SECTION 3

art is important......
ARTISTS ARE MORE IMPORTANT

The relations between artists (and between 'artists' and people) as central to the art process.

Kasia Januszko
Jane Hartwell
Margaret Ochocki
Karen Strang
Cris Cheek
Peter Ellison
Graham Harwood
Pete HoRobin
Karen Eliot

Artists in Bigos were **Lydia Bauman, Andrzej Borkowski, Martin Blaszk, Tessa Blatchley, Krystyna Borkowska, Margaret Bialokoz Smith, Jerzy George Bort, Maria Chevska, Leszek Dabrowski, Mietek Dymny, Ruth Jacobson, Kasia Januszko, Louise Severyn Kosinska, Simon Lewandowski, Ewa Mann, Rosita Matyniowna, Jamoula McKean, Ondre Nowakowski, Margaret Ochocki, Jozefa Rogocki, Jola Scicinska, Stefan Szczelkun** and Silvia Ziranek.

ıckinson, Ed Baxter, Registrat
Glyn Banks, Suse Wiegand, Wen
Ian Sherman, Stephen Games,
son, Hero Jo, Chiron Mottrar
Carlyle Reedy, Mandy Bullet
Lukic, Fiona Daly, Dave King, Lʿ
)le, Dave Leapman, Nick Banks,

DATA CELL RUDD JANSSEN A. MONTY CANTSIN ROBIN CROZIER JURGEN KIERSPEL RYOSUKE CO-HEN JAMOULA McCLEAN ALEXANDER JOSEF HIRKA BIRGER JESCH JAN CHWATCZYK SHEILA HOLTZ CREATIVE THING JURGEN SCHOBERL STEFFEN JACOB SIXTEENTH STUDIO - GIOVANNI STRADA TERESA GIERZYNSKA ANDRZEJ DUDEK DURER MARK PAWSON CARLO PITTORE V.E.C. ROD SUMMERS DIAGONALE/ESPACE CRITIQUE PIOTR RYPSON LOIS WAY JURGEN O. OLBRICH MARK S. BLOCH DICK

our wonderful culture

No utopian tendencies but only the hope that wreckage will produce a form of communication and a recreated culture.
ART MONTHLY
Some may scoff, some may mock... but the message is clear: 'Today in a culture which seems to care less about people than its objects, it is time for art to go underground again.'
THE OBSERVER
A sort of guerilla creativity amongst the ruins and fragments of our cultural heritage.
ARTSCRIBE INTERNATIONAL
Making astute comments on the current state of play.
ART LINE
A display of anarchic optimism towards a do-it-yourself culture: a culture without curators.
PERFORMANCE MAGAZINE
A collective two fingers to 'art', 'quality' and 'good taste'.
ART MONTHLY
If art is indeed going to contribute to a fundamental re-evaluation of our ways of seeing and understanding the world, and that is certainly one of its foremost

functions, it is precisely this openness, this freedom from dogma while refusing to settle for cynicism, which is most needed.
ARTSCRIBE INTERNATIONAL

The exhibition which got this response was not organised by me but by Glyn Banks & Hannah Vowles with help from Hercules Fisherman and Armar. It was in the Crypt, St Georges Church, Bloomsbury, during December 1985. I participated with an installation and performance. It was here I met Ed Baxter and had discussions on our common interest in 'glamour'. And also introduced Karen Eliot to Glyn and Hannah.

INSTALLATION: 'Art in Storage' - art is important but artists are more important. A series of 13 drawings framed with red or black broomstick handles. The series had originally been conventionally exhibited at minor art venues under the title 'Routine Art Replies' (originally captioned with a series of questions.) The frames were piled horizontally with old wooden roadblocks separating each frame from the next.

83

Already the number of participants has grown and it may be that this is the first in a series of such exhibitions of Art in Ruins. For the moment it is expected that as well as a fashion show and various performances the exhibition will feature objects, furniture, installation work, painting, sculpture and architecture by Stephan Szczelkan, Martin Kennedy, Tony Gill, Kevin Rhowbotham, Rod Dickinson, Mike Harwood, Sophia Kelly, Hannah Vowles/Glyn Banks, Ed Baxter, Fiona Ray, Andrew Golding, Suse Wiegand, Nicky Frost, Registrate, Hercules Fisherman, Armar, Julia Wood, John Chaple, David Leapman, Ian Sherman, Stephan Games, John Webb, Rose Nag, Edward Woodman, Hero Jo, Chiron Mottram, Jim Hanlon, Frederick Takkemberg, Deborah Levy, Randy Bullet, Anne Twinn, Nanne Meyer, Matt Sindall, Jeannette Emery, Jelena Lukic, Fiona Daly, Dave King, Loveday Wright and others.

13 storeys of evil

PERFORMANCE: '13 Storeys of Evil'. The performance derived from the installation and the place and time of the performance which was Friday 13th and also the anniversary of the imposition of martial law in Poland.

Action one: I go around the gallery with an estate agent's folder as a catalogue muttering gobbledygook with an east europeanish accent, interspersed with details of property for sale. (See photo one.)

Action two: Decide to 'buy' my own installation (Art in Storage) but decide to remove the 13th storey to make it more profitable and to make the black and red symmetrical. This means removing a frame from the middle of the pile. I employ members of the audience to carry out this delicate operation. Using broom handles they lift the top 6 storeys and the 13th storey is removed. My 'employees' are then asked to use their brooms for crowd control during the rest of the performance.

Action three: I then make 'an example' of the thirteenth storey by hanging it from the ceiling with a blue rope. (Wino helps and gives good advice).

Action four: Tape of euro-nonsense song followed by tapescript. Remove a picture from the wall and take my place behind an empty broomhandle picture frame in Mona Lisa pose. (See photo three).

Action five: I stay by wall, tape playing. Yolande Snaith enters, takes a broom and does a series of heroic freeze poses derived from the functional uses of the broom.

TAPESCRIPT: *Isn't it time we applied some of the most basic discoveries of science to our own western societies? Even with the efforts of Marxism... we must realise that things have a CAUSE, a cause in real conditions. The devil may have been our best symbol of irrationality before (science) but now we must face up to our responsibilities and our own emotions. And find the cause of irrationality in ourselves.*

just for the record...

Answer these questions: Why is our art in storage? Why are empty office blocks more important than artists? Why do we artists compete like demons for grants just to cover our expenses? How do artists accept the humiliation of no living wage when other workers are fighting against wage cuts? Why can we not unite to demand that our needs are met?

just for the record...

Whilst our emotions are taboo we cannot bear to think through these questions... because let me say... humans are not intrinsically evil. We must not confuse the power of symbol with actual cause. Symbols like 'wicked satanist' and 'Friday 13th' should not be confused with the cause of the 'Brighton Bomb Outrage' or the state suppression of free trade unions, which is not to be found in such symbols.

just for the record...

Symbolically we can remove the 13th storey and have 12 nice storeys with its dozen familiarity of hours, months and apostles. But reality won't change until we can talk to each other.

We can take that which does not fit in, the 13th storey, the 21st young man and hang them as victims, symbols of our resentment. But tomorrow will be just the same unless we can express the deep fear which makes us hate ourselves so much...

just for the record...

84

85

86

Szczelkun, making the connection between Friday the 13th, his thirteen storeys and the anniversary of the imposition of martial law in Poland, made reference to the artwork as commodity and artist as symbol of freedom. Walking around the crypt muttering Euro-nonsense from an estate-agents' guide to property for sale whilst examining various artworks on the walls, Szczelkun, having removed one of his thirteen storeys, finally framed himself in Mona Lisa pose — the artist becomes a commodity whilst the audience becomes a crowd. With this performance he reminded us of the 'solitary' activity of the artist as one of forced exclusion,

87

BIGOS
Artists of Polish Origin

It was in 1984 when Kasia Januszko moved into my street that the Anglo-Polish project took off. That September a long exploratory letter was written to Michael Harrison in the Arts Council (of Great Britain) with the idea of getting official backing for a prestigious show of the better-known Polish artists involved in the British arts scene. This early group included people who later dropped out (Andrzej Jackowski and Hannah Collins) or who have taken a passive role whilst maintaining an interest (Maria Chevska and Adrian Wiszniewski). Other Poles, David Mach for instance, were known but not invited because at the time we were looking for work that had recognisably Polish content. This was because we were trying to persuade the Arts Council of the coherence of the group on the basis of a perceptible 'Polish' influence. Later these criteria were dropped when we decided to open up the group to all professional Polish or part-Polish artists.

Advertisements in *Artists Newsletter* and *Jewish Chronicle* to attract artists outside of our immediate London circle got a good response and the group grew from 12 to over 30 with more women than men. From then on the group itself became more important than the initial concept of a prestigious exhibition.

Just as this larger, more open, group had formed, the Arts Council, finally, sent us a letter of refusal, in which they said: *'(The committee) is not sufficiently convinced of the value of grouping artists in this way, although they have of course recognised that there are a number of very good artists amongst those you are putting forward'* (Michael Harrison, September 1985).

Riverside Studios had also decided not to have our group exhibit and the GLC had given us a 'low priority'. The question we now had to decide was whether our presentation was at fault or whether, as the Arts Council reply suggested, there was an in-

REPRINTED FROM ARTISTS NEWSLETTER, MAY 1987.

built Establishment resistance to giving support to exhibitions representing the culture of emigré or immigrant communities.

Cultural Survival

The application to the Arts Council was composed of a descriptive background to why an exhibition was planned and how the group was operating. Poles have always tended to accord with the British requirement of the speedy integration of foreigners, welcome whilst they adopt the most respectable of English mores. In public the Poles have complied as much as their awkward names and accents have allowed. But Poles have a deep tradition of resistance to cultural attack.

From 1772 to 1795 Poland was partitioned by its neighbours and from 1795 until its liberation and reunion in 1918 was supposed not to have existed. Polish culture survived this long occupation underground. Again in World War II the Poles resisted attempts to erase their culture with strong underground organisation. This is the tradition that Poles bring with them, not only expressed in autonomous schools, clubs, dance groups, etc., but also within people's personality – I think it may explain the tenacity of Polish cultural influence within the individual Anglo-Pole. Catholicism played a major part in Polish cultural survival and as such is more than a 'religion' to many Poles but an integrated part of Polish identity. This has been exploited at times to create divisions between Poles who are Jews and Lutherans, etc., and the majority of Catholics. Within this context of cultural survival, connections to European art have been particularly important. The internationalism of the western modern movement has been invaluable in combatting Polish isolation. Polish contributions have been considerable, especially in the fields of performance (Kantor and Grotowski) and film (Wajda, Polanski, etc.) but even so it is the connections in the field of fine art that are perhaps most valued. Art is much more a part of popular culture than it is in Britain.

It is then surprising that there has never been a show of the excellent Anglo-Polish artists working in

the UK . . . A show would not only give insight into the emigré experience but also release Polish creativity in the evolution of British and Euro culture. A policy of art presentation and distribution which represents the various cultural groupings in Britain as well as encouraging the highest standards of artistic production is becoming an urgent necessity. The inclusion of minority cultural groups within the art show circuit will enrich the continual debate and reassessment of what constitutes aesthetic judgement and standards within the international art world.

This thinking would only run contrary to those who believe that the only worthwhile art should comply with immutable/eternal/absolute aesthetic values . . . It seems important that we now move on to recognise what is culturally specific, what is fundamentally universal and the relationship between the two. It would seem that a pragmatic and ordered approach is required as a theory cannot be developed without developing also our viewpoints (listening to viewpoints not our own). What I'm suggesting is that a true working universality comes from an understanding and acceptance of differences or 'starting places'.

Inaugural Meeting

The group was formed as a democratic entity at an inaugural meeting in November 1985 and in order to survive financially, a £10 subscription was levied to cover the cost of regular newsletters. The group decided to rework the commentary used in the application into a standardised format to use in a catalogue. The debate then began about whether we should concentrate on exhibiting together or on inter-group communication. The latter argument may be represented by Janusz Szczerek's proposal, the essence of which is described here.

'We are individuals with different approaches and attitudes working in various media. There is our background which got us in touch. Now, apart from our individual activities, we can form a team . . . each of us would direct his/her activity to the other participants. This would enable the realisation of individual often extreme programmes of work with feedback from the rest. It would result in a creative system of feedback replacing the self-acting artist and passive recipient . . . an alternative to art as a consumption.

We would see the need to confront the value system established within the group. Therefore we would do documentation of our work and pass on to other people in various ways: shows, exhibitions, discussions, posters, booklets, video documentation, etc'.

On the other hand many people were clear about the need to have a group exhibition.

'I would have thought shared nationality a very good basis for forming a group or exhibition. Subtitling (theme) may confuse your aims and identity in the eyes of the public and detract from the important subject of Anglo-Polish art per se'. (Margaret Ochocki).

The continuing discussion and controversy about exactly what we were doing together resulted in the following paper by Jamoula McKean.

'Why Anglo-Polish Art Exhibition?
The first question is what is Polish?

Polish is being part of a country which after hundreds of years has finally got a concrete piece of land internationally recognised as its sole right. Polish is being part of that struggle to get this right, and to keep it.
What is Anglo-Polish?

It is being a second generation Pole, neither English nor Polish, but the two combined. It is alienation from both countries, neither being comfortably 'home'; but both feeding the individual with its culture, prejudice, patriotism, cults, humour, ideals and national phobias/anxieties.

Poland is seen largely from the point of view of parents who 'escaped' or were 'evacuated' some forty years previously, and who carry with them the Poland of what it was like then. Sure, they've been back, visiting. Sure, they send food parcels, and support the striking miners . . .

The very recent upheavals that have led to our parents' exile were conducted with pain, bereavement, resentment. Even non-Jews were gassed in Auschwitz.
And who recognises the right of those in exile? Those who remained also suffered, but they are home, whatever that is. Those abroad belong to a no-man's land that is possibly a timewarp, in a host country that has virtually no understanding, having no parallel in its recent past. Sympathy is not 'understanding', it is being charitable.

A new role for the dispossessed has to be worked out . . . There has to be a comfortable marriage between the host country, which is home, and the strong cultural home of our parents'.

Towards Redefinition

Two members of the group (who do not wish to be named) wrote a critical paper, 'Towards Redefinition', which was circulated in early 1986. In this, they objected to our name, which was then the 'Anglo-Polish Artists Exhibition Group', which they saw as a limitation, and to the idea of an 'Anglo-Polish hybrid'. They stated their identity clearly as foreigners rather than 'half' anything. Polishness was not seen as central to their existence and they

THOUGHT IS

True Infinity means
Self Determination

INFINITE

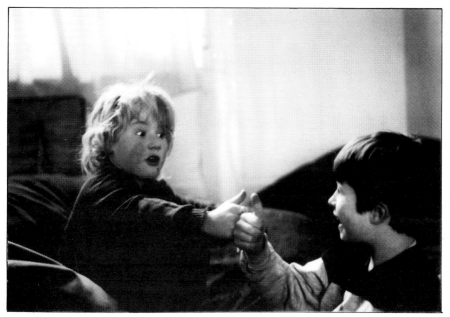

The Infinite is the Unity of Something and Other

wanted to reject the 'emigré' definition with its association of 'victim'.

It also pointed out that we were in danger of promoting myths about a 'Polish spirit' and 'Fate' and, with it, *'a romantic vision of Poland as sufferer'*. This referred in one instance at least to our making connections between our situation here and the recent situation of artists in post Solidarnosc Poland. *'What is radical and alternative there derives from the social and political situation which is not comparable to the situation here'*.

They said, *'The struggle for us is not defined by Polishness. It has a wider scope – displacement faced by all artists today. The question is not of mainstream or margin, it is a struggle for integrity of one's own position'*.

The Response

Jozefa Rogocki wrote in response:

'Positive response to opinions being expressed in this way opened up the debate. It was suggested each individual gave their reactions to it and one of the authors said initially that it was written to shake up the proceedings a little and gather people's opinions on the issues raised.

A major question arose in the realisation of the difference between the Polish members who presently live in England and the English members with Polish ancestry. Stefan recognised that 'Anglo-Pole', as a title, reflected his viewpoint, on which he expanded. He suggested that a revised group structure should take into account much more the differences between people to the possible extent of small groups forming according to special interest, as in the Women's Forum, although he emphasised the gains in being a diverse group.

Generally a 'name' was seen as a starting point which could be changed or dispensed with, according to the group's expression through the interaction occuring under that 'name'. No shared philosophy was deemed necessary for this cross-section of persons to function as a group'.

'I'm very grateful for this contact with Anglo-Polish artists and would hope that sharing ideas, feelings about our unique situation could lead to some work, independently or together, worthy of exhibiting because of what is communicated about our experiences. But why exhibit now, just because we're Anglo-Polish? Would it not be better to work around that idea, 'A Voyage Around my Father' perhaps, and see what that leads to in terms of an exhibition together, stemming from what we all discover?' (Excerpt from a letter from Julia Szoka)

These discussions led to the reconsideration of our name from Anglo-Polish Artist Exhibition Group to 'Bigos'.

By the beginning of 1986 we had 20 paid-up members and made an application for exhibition funding to the Greater London Arts. Finally this was a success and we received £500 and some recognition of our project which such an award confers. Brixton Gallery also contributed £350 towards exhibition costs which, along with Simon Lewandowski's labour, has made the catalogue possible.

The group's newsletters, which were circulated about once a month, were open to contributions from any person in the group. I had a particular interest in opposing anti-semitism and so circulated a batch of information which was followed by some discussions and correspondence. It was in fact not long before we experienced anti-semitic and anti-gay remarks made at the *Six Polish Women Artists* show at POSK in April 1986. The GLC funded Polish Women's Forum had invited women from our group to exhibit as part of the forum.

Six Polish Women Artists

'This exhibition provided the first opportunity to see how the work of at least a few members of our group looked together in a gallery context'.

There were, true enough, 'Polish' elements in the work of all the contributors, but they were perhaps not strong enough to assert themselves in any unified expression in such a small room. There was the specifically Polish humour in Ewa Mann's colour drawings, and the Polish love of irony in Krystyna Borkowska's collages. There was the quintessentially Polish imagery of war memorials and roadside saints in Kasia Januszko's photographs from Poland. The traditional Polish craft of paper cut-outs was put to use by Jola Scicinska, but the very un-Polish end of feminism and as protest against the persecution of Jews and gays in today's society.

It was a bitter, though sadly not unfamiliar, experience – for someone born and bred in Poland – to find that the reaction of the majority of Polish regulars was not exactly that of art lovers: shrugging indifference and misunderstanding at best; vicious, almost fanatical railing against Jews and homosexuals at worst, accompanied by righteous cries of scandal, shame and corruption. The visitors book bore (unsigned) slogans, which were nothing short of Nazi in sentiment. This reaction was well fanned in advance – the exhibition was paid for by GLC's 'Red Ken' and was therefore 'communist'.

Little did we know that as our hands were reaching out to the older generation in the romantic notion of 're-establishing our roots',

the hands of the older generation were busy ripping down posters advertising our exhibition, in the hope of ruining our chances through lack of publicity. If this is what 'our roots' are about, aren't we better out of it? (Lydia Bauman).

The Brixton Exhibition of BIGOS is our first exhibition open to every member of the group. Whether or not a Polish quality may be perceived in the work exhibited may not be the most important question. What is perhaps of more interest is the recognition of this particular foreign element in British contemporary culture and its relation back to Poland. It may be the links that are being forged between people that will be of more importance than any specific questions of commonality of content or historicism within the work.

'Being of Polish origin has always affected my own view of art making. The experience of being brought up in the U.K. of foreign parentage has left me with a great distaste for nationalistic jongoism and all the near-sighted aspirations for humanity that come with it (Poland knows this more than most!). . .

. . . We as Poles display to the world our Polishness (whatever it is, it is within us) by displaying ourselves as individuals as Poles. My view is that: the group should base its philosophy on the widest sense of liberty which it can contain; it should concentrate on making each other aware of our work; we should aim to put together an annual show (which could tour) (the first show will be important!); we should get to know each other as friends . . .' (Excerpt from Ondre Nowakowski).

Exhibition Report . . .

The following is taken from the Brixton Art Gallery Newsletter following the exhibition.

'Due to the efforts of Andrzej Borkowski, Kasia Januszko and Krystyna Borkowska, the exhibition was attractively presented. Simon Lewandowski sweated in the Ormond Road Community Workshop to produce 500 copies of our catalogue with genuine glossy card cover for the price of paper and binding. With its 'intriguing' (City Limits) introduction, compiled by Stefan Szcelkun from contributions collected by members over the last year, it has stood us in good stead as a publicity tool. Frenetic posting of the catalogue as the show started led to good reviews in City Limits and the haughty and dubious Times.

The group has taken initiatives against anti-semitism, attempting to become better informed about the historical facts of Jews in Poland and trying to ensure that Polish artists in the UK are not divided into Jewish and Gentile camps. I hope we have also made it publicly clear that anti-semitism will not be tolerated by the group.

Through the process of meeting as a group and distributing a newsletter we are working together as artists rather than simply coming to together to promote Polish culture or to further individual art careers. The group contains more women than men (fourteen women, eight men) and a wide variety of artists from different walks of life, styles of working and media. The fact that we can get together as artists through our 'shared' origins is a positive move towards unity and taking control of our destiny as artists.

Our other achievement is the recognition that cultural displacement is an issue that can have profound and often hurtful effects on people's lives within the context of an oppressive society. This experience of 'displacement' is shared by many Londoners, be they immigrants or 'upwardly mobile' working class. By coming together to clearly celebrate and share our 'Polishness' (just as we are, rather than in contrived or traditional form) we can change our alienation into a positive force for human liberation'.

Where now?

Since last year we have been trying to organise a touring show as it makes a lot of sense to tour, especially those towns and cities with Polish communities. The difficulty is in finding an administrator to organise and fund-raise for it. A touring show is a different kettle of fish to a one-off open show. It needs a tighter theme, a selector, a sponsor and someone with experience of touring venues to bring the whole thing together. This is not an easy thing for a large unfunded group to get off the ground. As the Arts Council won't consider a grant until the show is formulated and venues have been found to show interest, where can we get the money to do this initial research?

Already we've decided on a theme/title DIS PLACE MENT and unless we can find an administrator, we'll have to evolve a touring show at a London venue next year. Once a show is formulated within the 'touring' format we feel confident it could also travel abroad.

Another problem is in involving 'name' artists in the same show as 'unknown' artists. Well-known artists are also wary of being involved in a show that could be labelled 'ethnic', by now a well known way of marginalising artists. It is a problem of prestige. Funds are more easily found for a small show of 'elite' art stars. We would prefer however, to stick to our more-open ended collective approach. For me this is a recognition that art is a complex social and cultural phenomenan rather than a simple striving for the work of transcendental quality.

Stefan calls on new image

IF YOU'RE Polish and you live in Swindon, be prepared to have artist Stefan Szczelkun pop up unexpectedly on your doorstep this week.

Wheeling before him a quaint and curious house on wheels, and bearing traditional gifts of bread and salt, Stefan will be dropping in on Polish homes picked at random from the Swindon phone book.

There he will engage families in friendly banter, before snapping photos of them and their homes, and posting said photos up all over the mobile mini-gallery.

Object of the exercise is to build up a picture of Swindon's Polish community, as part of a unique arts project being run in the town this week.

Stefan and colleague Kasia Januszko, pictured here, are taking part in several days of image-making, which will culminate in a day-long celebration of Polish culture at the Town Hall on Saturday. More of that elsewhere on this page.

Portraits, prints and drawings by the pair have been on show there for the past fortnight. They'll soon be joined by work produced by them in Swindon this week.

Abandoned

Culture Club caught up with Kasia and Stefan at the weekend in the industrial tomb of the BREL works' derelict coach-building shop, where Kasia was preparing prints for the show.

Her raw material was stacks of abandoned steel plates, punched through with cuttings that had gone to form anything from shelf brackets to hooks.

Carefully sprinkling pre-mixed pigments over the gutted plates, Kasia then pressed thick, moistened paper on to them,

taking at once a coloured image and also a relief imprint of the perforated surface.

It's a technique the 28 year old artist has used before to portray manhole covers and other street ornaments, most notably in a show entitled Roadworks, seen last month at London's Brixton Gallery.

Turning such industrial detritus into beautiful images will have special significance for Swindon people, Kasia believes.

"I hope they will enjoy recognising shapes they might have seen in their working lives," she said.

Warsaw-born Kasia specialised in print-making on her degree course at Camberwell School of Art. But she's

also worked in photography, and taught life drawing.

She and Stefan, 38, are members of Bigos, a newly formed group of around 30 artists of Polish origin, which mounted the recent Brixton show.

Bigos, explained Stefan, is a rough Polish stew, into which all kinds of ingredients can be mixed.

Litter

"It's a useful metaphor for the way we work — singly, or in groups," he added. "We are not cultural ambassadors, but it's nice to have a common background from which to draw support."

His own work with the mobile structure — his

"art house" — sprang from an arts outreach project in London's Vauxhall last year.

Earlier he toured it round Huddersfield, collecting (literally) rubbish off the streets, spraying its outlines on the walls, and putting the painted house on display with framed pieces of litter arranged around it.

The Swindon show will be less experimental, combining photo-documentary with a "meet-the-people" exercise.

You should be able to judge Stefan's and Kasia's efforts for yourselves when they go on show at the Town Hall later this week.

● ARTS DISCUSSION ... Stefan Szczelku and Kasia Januszko reproducing the patterns of industrial life as it used to be. They're in the coach-building shop of the derelict BREL works. Picture by Erik Hansen.

Evening Advertiser
7 October 1986

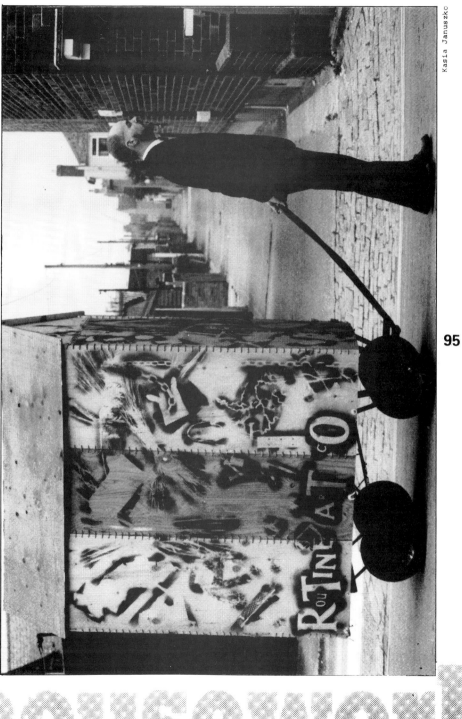

95

bread 'n' salt

Starting at 12 noon precisely (as it happened by chance) on Sunday October 5 1986, from the Town Hall Studios, Swindon, where the house structure had been delivered from Huddersfield Art Gallery, we set off east down the Groundwell Road. Kasia Januszko was helping me by doing the photographic documentation and helping out with the 'meetings' when Polish language was required.

I had researched a circuit of Polish surnames to visit by tediously going through the entire Glouscester telephone directory and then transferring this information to a local town map.

The first stop was the Polish shop STACH, no.1 Groundwell Road, were we caught them just before going to church. Mr Stach was reserved. I offered him a bread roll wrapped in white tissue and salt in a twist of red tissue. I also showed him my house parked on the pavement in front of his shop. But he didn't really relax until his wife came out and Kasia came over to speak in Polish.

Mrs Stach was very efficient about preparing the shop front for its photograph. We left on good terms... a good start.

The next stop was further down the Groundwell Road. The people were out (at church?) but I left 'bread and salt' on top of empty milk bottles with a ROUTINE ART CO London/Warsaw calling card.

Next stop... Husband out at work. English wife took it all matter-of-factly. We explained to people about the context of the event in the coming Polish Day at the Town Hall Studios. People in the next two houses were out. Left bread & salt.

Next house was the Kucharski s . Polish man from the mountains with an Italian wife. He was ill until he saw the little house whereupon he got quite excited and posed looking out of the window, as well as the usual photo in front of his house. Then we went in for a longish coffee and biscuit session. Only here did we have long enough to exchange anecdotes. We then realised we could only stop for a limited amount of time if we were to complete the six mile circuit that day.

And so it went on through the day. From then on more people were in. We travelled from 12 noon until seven o'clock, stopping only twice for coffee and lunch in a little cafe that happened to be open next to a target house in Wellington Street.

Reaction ranged from bemused or disinterested to enthusiastic and welcoming. There was never any hostility and quite often the arrival of the house and gift of bread and salt was accepted as reasonable behaviour.

I liked leaving our cryptic gifts when people were out... in the porch or with other people in the house - and imagining what they made of it when they came home. On the following Tuesday a newspaper report came out of our activity and in the meantime we had the photographs developed and sent all the people we visited a photo of HOUSEWORK visiting their house and a Town Hall programme. Hopefully this would ensure that the activity as a whole took on some kind of mythical quality through gossip and would become exaggerated and distorted as it was retold.

The next day someone called Neil helped me frame the photos in the little gold frames I had bought for the 24 Masterpieces collection of shanty house photos that I had exhibited at the Brixton Bigos show and at Huddersfield. The photos were developed and printed in a one hour process on Monday morning. I spent some time stencilling the names of the Poles we had visited on the blue front door of the HOUSEWORK structure. The little house was then taken into the foyer of the Town Hall Studios and the photographs were hung inside so that they could be viewed through the windows. A lamp was fixed up inside the house.

Thanx to Alistair Snow and family for his help and hospitality. My installation in the Town Hall accompanied Kasia Januszko's monoprints made in Cutting Shop 31 in the vast, dying railway works.

The art is in the meeting. But also in the recognition of Poles as an integrated part of British culture as well as autonomous exile communities.

bread 'n' salt

kasia Januszko

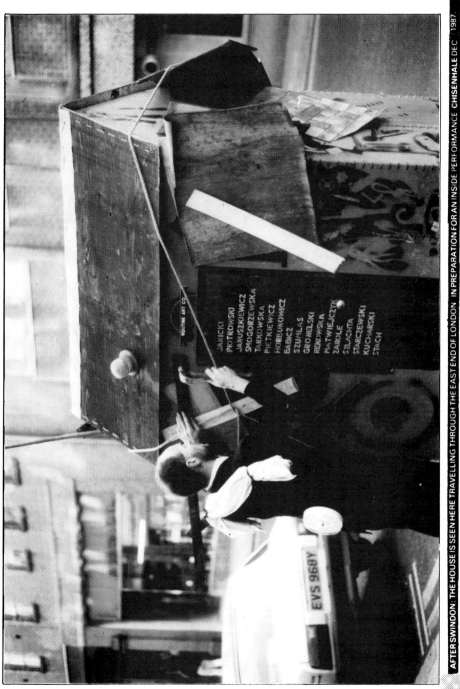

Ghislaine Boddington

AFTER SWINDON: THE HOUSE IS SEEN HERE TRAVELLING THROUGH THE EAST END OF LONDON IN PREPARATION FOR AN INSIDE PERFORMANCE CHISENHALE DEC 1987.

JANICKI
PIOTROWSKI
JANUSZKIEWICZ
SMOGORZEWSKA
TARKOWSKA
PIETKIEWICZ
HOREUNOWICZ
BABICZ
SZU^HLAS
GROMELSKI
REKOWSKA
MATWIEJCZYK
ZAROLE
SZLACHTA
STARCZEWSKI
KUCHARSKI
STACH

ROUTINE ART CO.

EVS 968Y

postal art

my locality. The artist then gets back a colour print of the work in location and a group documentation booklet. The photos also serve to describe aspects of the environment in which I live. The 'postal art' changes my environment and I can observe what happens to each piece of work in time. I had certain particular reasons for doing this project.

Postal artists tend to collect archives of work they receive. Often work is only glanced at by the artist before it goes into the archive. The archives may become valuable but there is a delicate tacit agreement not to market work that you receive through the network. These archives seemed to me a dead space. My aim was to experiment with some more open and public use of postal art which avoided the pitfalls of accumulation and collectors. These ideas link up with the *ART MUST GET OUT* experience which informed *ROADWORKS*

The International Postal Art Network I.P.A.N. is a worldwide network of several thousand artists who communicate and run projects amongst themselves through the worldwide postal system.

Projects tend to have a theme and certain conditions which are: that all work is accepted without fees, that work is not returned and that all participants are sent documentation of the project. This documentation is at minimum a list of the names and addresses of all the participants but can be quite sophisticated catalogues.

Receiving mail art is a nice way to start the day but it can be really annoying to send out a fine piece of work and perhaps not receive documentation or even, occasionally, a simple acknowledgement... this leads people to send out cheap xerox work except to those people with whom they have built up some trust; or to correspond in more detail with a smaller circle of artists.

POST ART I & II. My main project within the International Postal Art Network was to ask for work which I would then install and photograph on carefully chosen sites in

POST ART I & II allied its practice with that of the vandal and signer† in conscious contrast to elitist art practice. If this practice of posting up works became commonplace, if people could bring out all their repressed expression into the street, could certain public spaces become permanently changing shows of cultural celebration and expression? My imagination can just perceive of such a possibility. Is this a form that a widespread working class art practice might take? Between the city signers and the Sunday painters on the village green there is a flicker of the human spirit by which people could begin to make city spaces their own.

†*FOOTNOTE:* The Signers, by repeating their stylised signature hundreds of times throughout the city, can compete for public renown with commercial products, but with nothing to sell but their 'name' tag - their fame - countering the obscurity and alienation forced onto us by the commodity in a very direct and effective way. It is now a common and active popular art form.

And what of the *I.P.A.N.*? Recently I watched an old woman paying the final £5 of her TV licence saving stamp book and all the palaver there was with the Post Office clerk rubber stamping and re-sticking paper stamps, then the licence form with all its own stamps, rubber stamps and signatures. It was driving people in the queue crazy. What a waste of (life) time.

Is not mail art with its rubber stamp aesthetic celebrating this life of meaningless postal emissions and circulars, bills, licences and taxes rather than just sending it up? It hints at the possibility of a discourse about how we could replace such a banal waste of life with a richer means of mediating our social organisation but never seems to realise it. At the moment it hangs fire in a kind of intuitive limbo, unaware of itself and its social meaning. Having risen in response to our condition, its existence as reflection is not enough to change anything.

Another *I.P.A.N.* practice, 'Tourism', can fall into the same trap. Tourism, one of the few expanding industries in capitalism's bleak industrial landscape, becomes another reactive mirroring of *I.P.A.N.* practice. Until 'Tourism' takes on the Tourism industry and challenges it, it stays fatalistically within mechanistic history.

In short *I.P.A.N.* holds all the possibilities and difficulties of the new artist networks that are growing everywhere. The uniquely exciting and hopeful thing about Postal Art is that it is global and open to all.

DATA CELL, RUDD JANSSEN, A. MONTY CANTSIN, ROBIN CROZIER, JURGEN KIERSPEL, RYOSUKE CO-HEN, JAMOULA McCLEAN, ALEXANDER JOSEF HIRKA, BIRGER JESCH, JAN CHWATCZYK, SHEILA HOLTZ, CREATIVE THING, JURGEN SCHOBERL, STEFFEN JACOB, SIXTEENTH STUDIO - GIOVANNI STRADA, TERESA GIERZYNSKA, ANDRZEJ DUDEK DURER, MARK PAWSON, CARLO PITTORE, V.E.C. ROD SUMMERS, DIAGONALE/ESPACE CRITIQUE, PIOTR RYPSON, LOIS WAY, JURGEN O. OLBRICH, MARK S. BLOCH, DICK TOOL CO, PIOTR ROGALSKI

PHOTO DAY DUETS:

The idea is that two people arrange to spend one day together with one 35mm camera loaded with a roll of colour print film. The 'aim' of the day is to take 24 colour photographs. Otherwise the brief is open.

Suggested additional agreements:

1. That each participant should have right of veto on any photograph at any stage.
2. That two sets of prints will be made and each participant has a set. (In this particular series I'd like to keep the negs and pay development costs.)
3. Text may be added to the photographs and any other conditions of showing should be a matter of formal or informal agreement between the duo.
4. Each person agrees to make as few preconceptions about the day as possible so the possibilities of spontaneous interaction may be as open as possible.
5. The day should start and end at a particular time, e.g. nine to five; or from dawn until dusk.

Photo Day Duets
By Stefan Szczelkun with Peter Ellison, Graham Harwood, Peter Horobin, Karen Eliot, Cris Cheek, Karen Strang, Kasia Januszko, Jane Hartwell and Margaret Ochocki

PHOTO DAY DUETS are like very basic collaborative photographic sketchbooks. The pictures taken can be anything from random documentation of a day spent together to a series that form a story-board. This format allows two 'artists' to spend a whole day together with the focus on their joint selection of a series of images. My idea is to look at how images may be derived from life within this elementary social frame and in the process get to know another image maker.

This is the *draft* framework as it developed by 18-12-86. *ROUTINE ART CO.*

DUETS:

Photo Day Duets are a new visual art form coming out of Szczelkun's experience with *Contact Improvisation* in the late '70s and experiments with the latest machine colour print technology. A simple way for people to meet and make images together, it appears to have many possibilities. The exhibition will show the first nine, selected by Szczelkun's collaborators, in enlarged and framed in a conventional way.

This approach had its precursors in the Fluxus era which Szczelkun experienced though the *Scratch Orchestra* with which he was a prominent member in the early '70s and in his recent correspondence projects with the *International Postal Art Network*. The format is open for use and development by any two people with one camera. Endless variations of approach are possible on the basic economical framework. Although the results can be viewed as 'art products' it is more useful to see them as part of a process of engagement between one 'artist' and another 'artist' and the world. This could lead on the one hand to more formal Art products or on the other to deeper relationships. The results give an unglamorous, direct, fragmented and realistic picture of the world we live in. It makes objective the visual values of the collaborators. Overall it provides a complex and subtle picturing of our culture.

PETE HOROBIN

KAREN STRANG

MARGARET OCHOCKI

PETER ELLISON

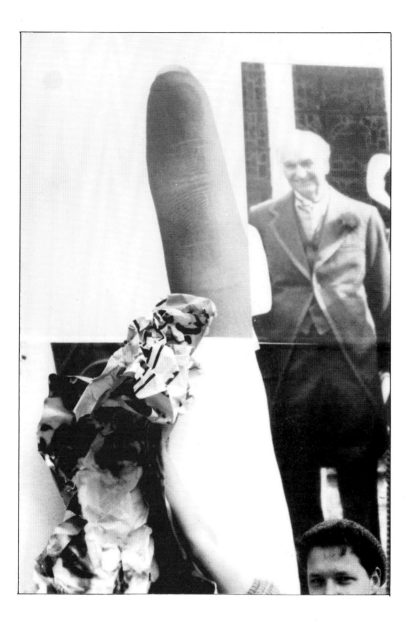

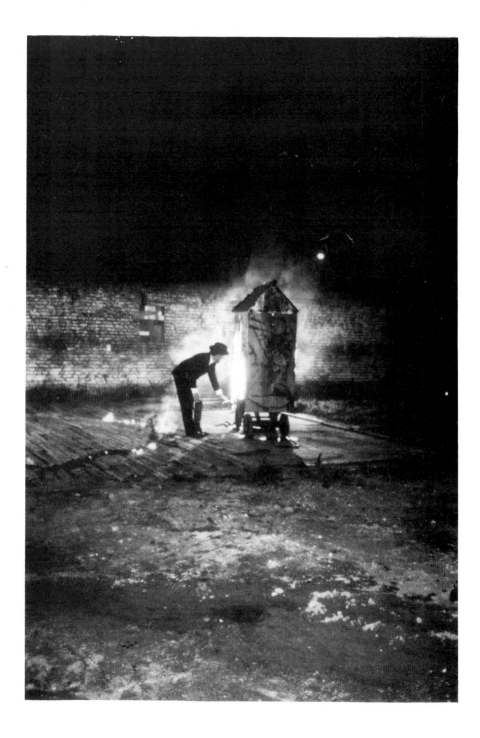